CW00341673

GET THE PHOTOS OTHERS CAN'T →

An Hachette UK Company
www.hachette.co.uk

First published in the United Kingdom in 2020
by Ilex, an imprint of
Octopus Publishing Group Ltd
Carmelite House
50 Victoria Embankment
London EC4Y 0DZ
www.octopusbooks.co.uk
www.octopusbooksusa.com

Distributed in the US by
Hachette Book Group
1290 Avenue of the Americas
4th and 5th Floors
New York, NY 10104

Distributed in Canada by
Canadian Manda Group
664 Annette St.
Toronto, Ontario, Canada M6S 2C8

Publisher: Alison Starling
Commissioning Editors: Frank Gallaugher and
Richard Collins
Managing Editor: Rachel Silverlight
Editor: Jenny Dye
Editorial Assistant: Ellen Sandford O'Neill
Art Director: Ben Gardiner
Designer: Leonardo Design Studio
Picture Research: Giulia Hetherington
Senior Production Manager: Peter Hunt

ISBN 978-1-78157-749-3

A CIP catalogue record for this book is
available from the British Library.

Printed and bound in China

10 9 8 7 6 5 4 3 2 1

GET THE PHOTOS OTHERS CAN'T →

Michael Freeman

ilex

Contents

Introduction

If you're truly interested in photography, you have to make a connection with what you're shooting. And to do this, you need access. Getting the photos that others can't is all about gaining this access to your subject.

Access isn't limited to the obvious. It goes all the way from gaining permission to be in a certain spot to the less obvious matter of getting your head around your subject. It's about how to get right up to that subject — not only so that it's there in front of your camera, but also so that you understand it and it responds to you. It can be a place, an event, a person or a thing, but it's only going to come alive in the picture if you have that access.

There's a creeping tendency nowadays to talk about photography in academic or philosophical or poetic terms, and I hope I've never fallen into that trap. Photography isn't vague. In the end, you have to deliver a picture, and that means really knowing what you're standing in front of and having made the effort to get there.

It's taken as read in this book that you've already reached the level of skill and talent to be able to make a good picture out of anything. If you need help in how to take good pictures, there are other books, and I'll be immodest and say that I've written quite a few of them, such as *The Photographer's Eye*. For now, however, let's just assume you can take a good picture if you're pointed in the right direction.

Stanley Kubrick, featured later in this book, and who was a truly great photographer, said about his film-making process, 'My background as a stills photographer makes it much easier for me to find an interesting way to shoot something at the last minute and not have to worry about how to shoot it.'

As you'll see, each photographer has a particular way of accessing what they set out to shoot, and there's great variety in their methods. Each situation, too, is unique, and it's essential to bring a fresh approach to each subject as you start to explore it. If I ever even begin to think 'Here's another one of those situations', I kick myself hard. Each one is new.

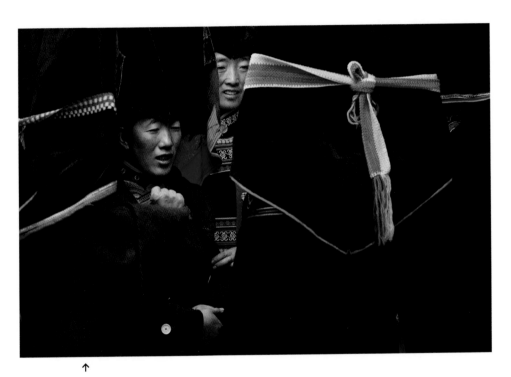

↑

Michael Freeman
Yi funeral, Yunnan, China, 2013

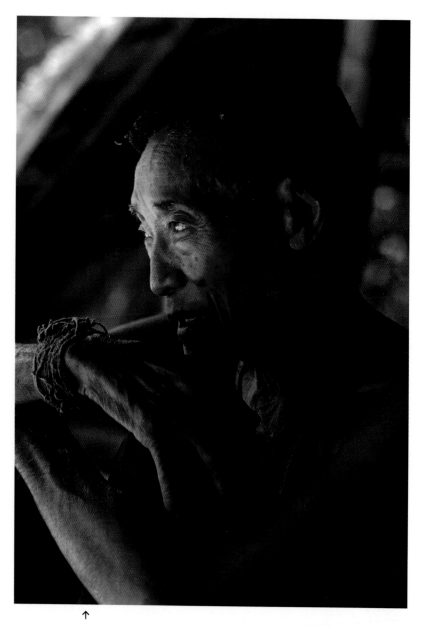

↑

Michael Freeman
83-year-old Akha man, Chiang Rai Province, Thailand

To give some order, however, I've grouped these many inventive approaches into five kinds of access.

The first is about being in the **Right Place at the Right Time**. The focus here is getting you and your camera in position. Even with fixed subjects, such as a landscape or a famous building, a good photograph takes due care and attention, because you don't want the shot that anyone else could take. With unpredictable subjects, the strategies become even more complex.

The second kind of access involves dealing with people, both as subjects themselves, and as the gatekeepers to something else you might want to photograph. People skills go way beyond photography, of course, and they certainly don't come with the camera manual, but they're essential and varied. We have a full suite of them here, under the title **Hearts & Minds**.

Third is **Immersion** in your chosen subject or situation. If you involve yourself fully, doors will open that you may not even have thought were there. The key ingredient of this form of access is time. Because the pace of most photography nowadays is fast, just making the decision itself to commit a chunk of your time and energy to a subject puts you at an immediate advantage.

Fourth is **Deep Learning**. Like Immersion, it's not what most people want to do, because it requires a lot of time and effort — but it always pays off. Knowing everything about your subject enables you to find ways of photographing it that have meaning, and gives you the ability to anticipate shots that might otherwise escape.

Finally (and when all else fails), step to one side and think of a completely different approach. **Left Field** means doing the unexpected, and I'll show you how some very creative photographers took innovative, even weird, directions to be able to get what they wanted.

Right Place, Right Time

'f/8 and be there' is the laconic recipe for getting the shot.

It's supposed to be the summation of all you need to know to achieve success in photography. Apart, that is, from all the other stuff you need, such as talent, knowledge, a good eye, and so on.

Some claim that the wise-cracking Arthur 'Weegee' Fellig (see Advance Notice, page 12) said it. Maybe he did and maybe he didn't, but he wouldn't have denied authorship in any case, because it cuts right to the chase of professional shooting. The first part (f/8) is about practical depth of field and depth of focus — both no-nonsense ways of guaranteeing the shot — while the second part (be there) wraps up everything that this book is about. Unlike writing, which I'm doing right now at a desk, photography can only be performed in front of the subject.

That's the simple part. Next, you need to know just what and where 'there' is, and that's the tricky part that this first chapter will help with.

What follows are mini case studies showing how photographers have used different techniques and ideas to get to the right place at the right time. I'm forever reminded of the words used by my first teacher when I started out in photography. Although he wasn't a photographer and teaching wasn't part of his job description, Lou Klein, the art director at Time-Life Books, my first big client, certainly gave great advice. On one assignment, to Athens, he said, 'I want to see what the milk bottles look like.'

Of course he didn't mean that literally. It was in the days when milk bottles in London were delivered to your doorstep, and he meant he wanted to dig into ordinary life, that what might be commonplace in that world could be fascinating to others. He also said, 'It's all about being in the right place at the right time.'

Sounds pathetically obvious, doesn't it? But if you take it seriously, it's actually the key to success.

Advance notice

Austrian-born and New York-raised, Arthur Fellig was the archetypal sensationalist press photographer, wise-cracking his way through crime scenes, street brawls, accidents and socialites on sidewalks. From the late 1930s through the 1940s, armed with a handheld 4 × 5-inch camera and flashbulbs, Fellig was the master of the scoop, priding himself on beating even the cops to murder scenes. Although prone to boasting and self-aggrandizement, he built up a reputation for being first on the scene. He called himself Weegee – a slang reference to the Ouija board — to further promote his seemingly uncanny ability to sniff out events.

In reality this was down to ingenuity and obsessive hard work. Weegee managed to become the only freelance photographer in New York with a permit to use a portable shortwave radio that could tap into the frequency used by the police. Working mostly at night, using flashbulbs, he often did reach the crime scene before the cops. The influential director of photography at the city's Museum of Modern Art, John Szarkowski, rated his work highly enough to include in the permanent collection, and wrote:

'Probably few policemen have seen as much violent sin as Weegee did. During his best years as a photographer he lived in a room across the street from Manhattan police headquarters, waiting for the inevitable call on his police radio that would announce another gangland execution, or botched holdup, crime of passion . . . mere professional competence would not have produced the wonderfully intimate and knowledgeable photographs that he made.'
– John Szarkowski

Weegee also learned something valuable from chasing violent crime — that the people who attended the scenes provided extra subjects. Weegee discovered that just as morbidly fascinating as a dead body was the behaviour of passersby at a murder scene. He paid attention to the onlookers who always gathered at these occasions and found that there he had access to human reaction and emotion. As Szarkowski put it, 'He had learned from experience that the audience was often as terrific as the event.'

↑

Weegee (Arthur Fellig)
Harold Horn, Knocked Over Milk Wagon with Stolen Car, 1941

Later in his career, in 1963, Fellig was hired by Stanley Kubrick (see Source Material, page 126) to document the filming of *Dr Strangelove or: How I Learned to Stop Worrying and Love the Bomb*. Kubrick had himself been a photographer for *Look* magazine in his early years, and he liked Fellig's style. Fellig's rather strong Austrian accent, incidentally, inspired Peter Sellers' accent as the ex-Nazi scientist of the film's title.

Although things have progressed considerably since then — in terms of technology and sensationalism — **thinking ahead and doing research are as valuable strategies now as they have ever been**. And the tools for research are better than ever.

Boots on the ground

Not everyone is interested in the rigours and difficulties, not to mention the frequent disappointments, of street photography, but there is a purity about it that can help teach all of us about access.

Street photography is more fashionable now than ever before, which is a mixed blessing. For the good, it has refocused attention on the value of skill in shooting. Less welcome is the idea that simply being out with a camera on a street is all it takes to get great pictures. It isn't. **The essence of street photography is the capture of some kind of coincidence that the photographer, and only the photographer, sees and is quick enough to catch.** By definition, this doesn't happen very often. Uncertainty and long periods of nothing happening are typical in this kind of photography, so it takes a certain kind of doggedness and optimism to persevere.

What this means in terms of access is that you need to simply keep at it. Getting prize captures in this kind of shooting is a little similar to old-fashioned gold prospecting — work at it long and hard enough, and every so often there's a nugget. You can't do very much planning or preparation, but you can arm yourself with expectations and get out there. Matt Stuart, one of the form's most renowned practitioners, admits to having an dogged approach: 'You have to be obsessed, you have to do it every day.'

And he really does mean every day. For 20 years. For at least a couple of hours. At the peak of his time street shooting in London, his routine was to leave the house at 10am and walk around until the light went, which in the summer in England can be pretty late.

'You have to be out there doing it. Gary Player, the golfer, said, "It's funny, the harder I practise, the luckier I get." It's the same with photography . . . The hit rate with photography in general, but with street specifically, is quite low, just due to the fact that you go out and wait to see what turns up, or you have to sniff it out. In a great year I'd get ten good shots.' – *Matt Stuart*

↑

Matt Stuart
New Bond Street, 2006

It takes real discipline to go out every day, even though Stuart says he's 'always totally stoked about shooting'. The picture above took him six months to get.

'I was walking past this advert with a peacock every day for six months and loved it, but nothing had really happened . . . Two weeks earlier, Joel Meyerowitz had contacted me and said he was coming to London, and why not go out and take pictures together? . . . Joel's a really inspirational character, and one of the things we share is the idea that you have to be positive, you have to be open . . . On this particular day, someone had dumped a skip in front of the peacock, and then covered it with a blue tarpaulin, and that was it. It's still one of my favourite pictures, and that was definitely one of my favourite days on the street.' – *Matt Stuart*

↑

Matt Stuart
Needham Road, 2005

Just walking a route every day, disciplined though it may be, is not enough on its own. You need mental tactics to ensure you are prepared. It helps to know the kind of imagery that you personally like, and to look out for certain 'triggers', as Stuart calls them, 'things you respond to'. His include people yawning, the colour red and people's hands (to name just a few).

'The first thing I look for when I'm walking down the street is colour and if I see someone in red — I have a thing for red — then I'll always go for that and see what happens. Unless it's a huge moment, like someone's fallen to the floor or doing a somersault in the air, in which case there's no time to think about colour and I'll just shoot. If you have a nice thing happening and you also have the colour, then you've probably got something.' – *Matt Stuart*

That was the intuition that led to this shot (opposite) taken outside a pub in West London — there were three reds and then something happened. Also, and this may seem self-evident but, **have your camera with you at all times**, even when, as in this instance (although you can't see it), there's a pint of beer in the other hand.

One of the added benefits of this sort of diligence is that you get insights that wouldn't occur to most people. The average weekly calendar usually denotes work versus time off, but Matt's is different. For his most regular beat, London's West End, it goes like this:

Monday: Delivery day.
Tuesday: The only ordinary day in the week.
Wednesday: Matinee day (so lots of grey hair on the streets in the afternoon).
Thursday: The new Friday. For people who live in London, Thursday evenings have become what Friday evenings used to be — after-work release.
Friday: Many real Londoners head off home after work, leaving the city to tourists and out-of-towners.
Saturday: Shopping and tourists.
Sunday: A rubbish day because it doesn't get going until mid-afternoon.

Do the math

If you want to raise the standard of your landscape photography to a serious level, the one essential variable to master above all others is light.

While you personally have no control over the sun and weather, they are increasingly predictable. There are powerful apps available that not only forecast weather conditions but also track the predicted positions of the sun, moon and stars. Examples of these are PhotoPills and The Photographer's Ephemeris. Ju Shen Lee, as a geographer, is a committed user of the former, in particular to check the direction of a sunrise.

A classic time for landscape photography is when the sun is low on the horizon, not only because of the colours present but because the low raking light offers extra choice depending on the camera's position relative to the sun. Capturing sunset is fairly easy, as there's time to watch the sun's path as it sinks, but sunrise is more difficult. First, travelling to a viewpoint and setting up usually has to be done in the dark, and second, the exact point on the horizon where the sun will appear is not easy to judge by eye. Moreover, this sunrise point shifts laterally throughout the year, more so in higher latitudes.

Visiting the Lake Tahoe area in Nevada for the first time, Lee planned for her shoot by first researching potential viewpoints, which included talking to local photographers. The spectacular view of Emerald Bay opposite can been seen from the top of Eagle Falls, and she recced the site during the day. 'There's just one projecting ledge that offers this view,' Lee recounts, 'with only a metre or two of space on either side.'

Apps such as PhotoPills have several tools for fine-tuning viewpoint and timing, and one important issue was whether the point of sunrise would be a good fit for the composition. Its position varies by over 60 degrees in the year, but Lee could confidently anticipate that its position at 5:32am on 22 May would work – just. She was concerned that the tree in the left mid-distance might hide the sun but luckily it rose just to the right. Lesson learned — use all available technology! (See Adapt Technology, page 124.)

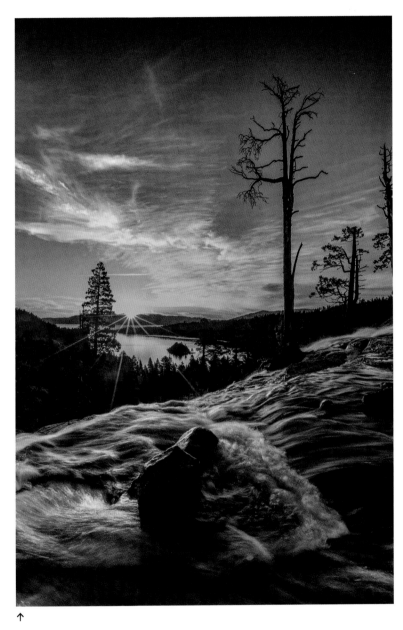

↑

Ju Shen Lee
Eagle Falls, South Lake Tahoe, 2012

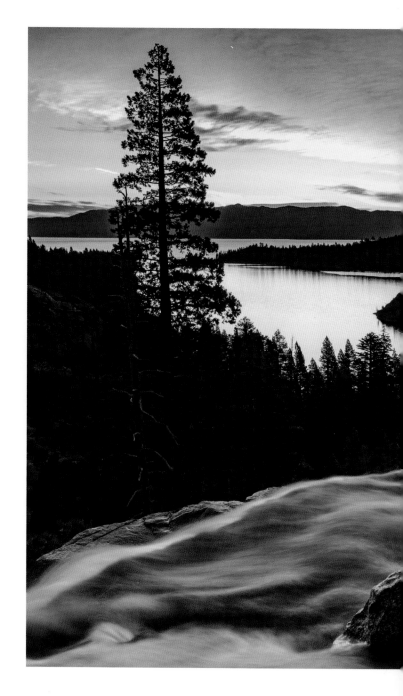

→

Ju Shen Lee
Eagle Falls,
South Lake Tahoe,
2012

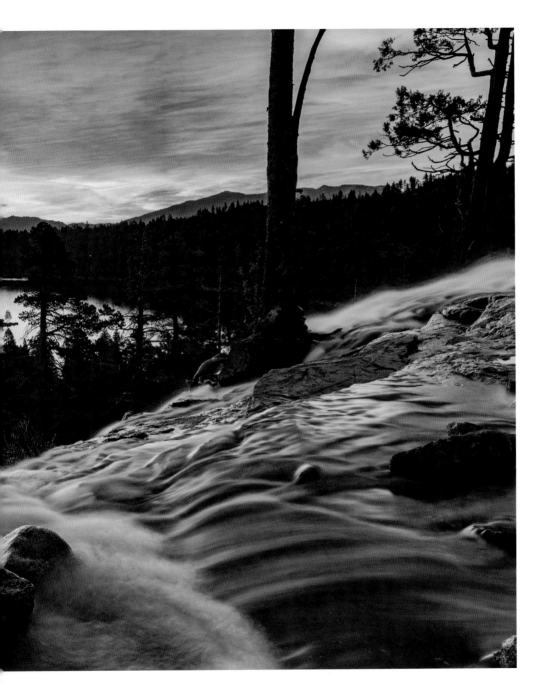

Return

Since the early 1980s, Bob Mazzer has been documenting life on the London Underground (known to locals as the Tube), almost every day. The result of returning again and again, and then making thoughtful selections from his images, is a rich and quirky collection that has become a photo story in its own right. Mazzer is one of those photographers who always carries a camera, so the steady accumulation of pictures was inevitable. Nowadays, of course, anyone who has a smartphone (Mazzer, incidentally, doesn't) is automatically 'prepared' with a camera at hand, one that even works well in low light. In Mazzer's early days, however, always carrying a film camera on the Underground required much more effort.

It began because the first job Mazzer was able to find was as a projectionist in an adult-movie theatre in central London, so his commute home was late. 'Every day I travelled to King's Cross and back. Coming home late at night, it was like a party and I felt like the Tube was mine

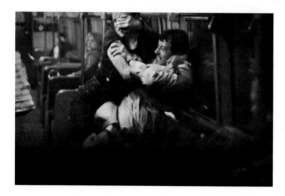

and I was there to take the pictures.' Two other photographers also famously did similar, though shorter, series: Walker Evans on the New York Subway between 1938 and 1941, and Luc Delahaye on the Paris Metro in the 1990s. The major difference, however, was that they used a concealed camera, while Mazzer is upfront. In his analogy, he joined the party rather than sitting apart from it (see Swim with the Fish, page 96).

Nor was he fixated on how his subjects — the temporary residents of the carriages and platforms — should appear. If it was a candid shot without the person noticing, fine, but if they turned and posed, also good. Late nights, particularly around the weekend, tend to produce more animated and exotic behaviour, which was all for the better.

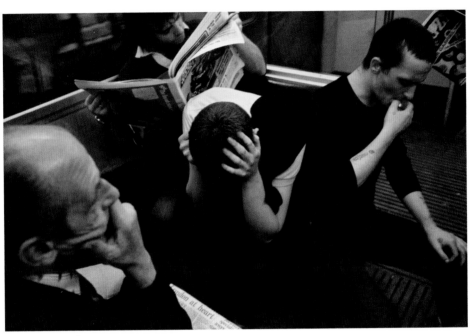

↑

Bob Mazzer
London at Heart, 1980s

←

Bob Mazzer
Fight, 1980s

Above all, Mazzer enjoys documenting life on the Tube. He says, 'I began to feel a real fascination and love for the Underground . . . I experienced a warm glow whenever I went down there.' And because the Underground is purely for commuting (only a very few people like Mazzer choose to ride for any other reason) it's a microcosm for the changing demographics of this large city, and the accumulating photo story provides a social history of London life. Back in the early days, he says, 'The Tube still had that old-fashioned quality,' a naturalness without the brand management and image management typical of businesses and institutions these days. 'It's a million miles from the image the Tube want to present now.'

The takeaway for all of us from Mazzer's long and happy relationship with his subject is that **repeated visits to one place, subject, situation or even idea always pay off handsomely**, for two reasons. One is the obvious build-up of valuable images that you have the opportunity to get from simply being there. The other is that such a project will draw you in and increase your knowledge and awareness of the subject, so that it increasingly 'belongs' to you.

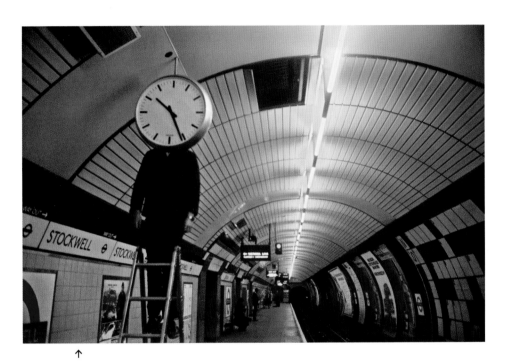

↑

Bob Mazzer
Clockwell, 1980s

Expert guidance

Most people's experience of professional filming is passing by a location shoot, and the usual reaction is to wonder at how many people are involved. Even a location-based stills fashion shoot can easily take a crew of a dozen. The reason is that every one of them is a specialist and they've all been hired for that reason. This is a different mindset from the way most photographers work. You must work in full-on professional mode and accept that it's going to cost. This is where location services come in, which include scouting, obtaining permits and creating travel itineraries — and this is where you can spend your money wisely. When Stanley Kubrick said to his production designer Ken Adam on *Barry Lyndon* (see Source Material, page 126) 'I need a stream just wide enough for an officer to jump across, with a hill in the background, and I need it tomorrow morning,' that's what he was paying for.

A professional guide who's used to working with television and film crews and photographers will be able to deliver not only what you're looking for, but also what you didn't know was there.

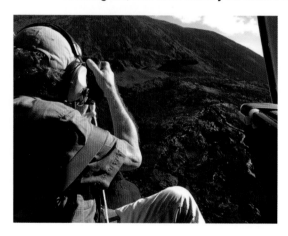

Feeling a bit stingy? If you're on location, you'll need your own transport anyway, so why not pay extra and have someone else take on some of the thinking and planning for you? A professional guide will work at understanding what kind of pictures you want, not just in terms of subjects, but also regarding style, and they will make suggestions.

When I was on assignment on the French island of La Réunion in the Indian Ocean, my professional guide was Nicolas Barniche, who came highly recommended by my client, a luxury resort based there. Over the course of two two-week shoots, he facilitated two thirds of the 70 shots in the book I was producing and was entirely responsible for making

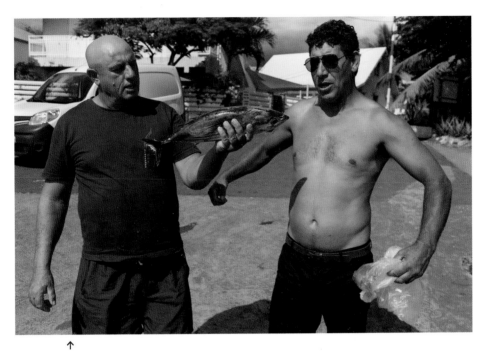

↑

Michael Freeman
Fishermen with bonito, Saint-Leu, La Réunion, 2017

←

Nicolas Barniche
Above the Piton de la Fournaise, La Réunion, 2017

↑

Michael Freeman
Above the Piton de la Fournaise, La Réunion, 2017

the other third happen, including several pictures I would never have thought about on my own. Nicolas made it his job to understand what kind of pictures I needed and even how the book was going to be laid out — for example, that we needed an overview landscape of this place followed by an extreme close-up of nature, followed by a people shot.

I wanted to get across a sense of Creole life. The word Creole means something special on La Réunion, where it stands for 'island born'. I wanted to capture life being lived, people interacting, not minding me and my camera. Nicolas took me to the small harbour at Saint-Leu to see if there were any fishermen around. A couple of guys had just landed with a small catch of bonito. We started talking, and Nicolas then started joking to get them to be interesting for the camera. They started horsing around, and that was it, I got the shot on page 27. **Nicolas knew what I wanted and just jumped in to make it happen. That's the value of seeking expert guidance.**

La Réunion is a volcanic island and one of the physically most dramatic places I know, parts of it a cross between *Jurassic Park* and *Avatar*. Helicopter rides are the only way to get there, and these trips are a popular tourist attraction, but shooting from a helicopter is a little specialized, as you need to be able to open a window or a door (not normally permitted), and you want the whole aircraft to yourself so that you can direct the pilot to particular viewpoints. That needed some negotiation. Ours, organized by Nicolas, was ex-military and very good indeed. But the real problem on La Réunion is the unpredictability of the weather, especially over the active volcano in the south. In all we had about six bookings that were no-gos before finally succeeding. I used some of these bookings to fly over other areas, while the helicopter company kindly allowed free cancellation on others (there were enough tourists to take up their bookings, but in other circumstances you should discuss potential cancellation costs well in advance). It was almost the last shot on the assignment and it capped a set of pictures I was pleased with. It would have been a much, much, lesser book without Nicolas, the professional guide.

Destination workshop

The closest you can get to guaranteeing a successful shoot is through signing up to a tailored photo workshop in an interesting place, and they've become very popular because they're a kind of holiday with a focus. The typical format is a few to several days in a location that has photogenic qualities, either for its landscape or its people. Events such as a festival are particularly popular – for instance, David Allan Harvey (see Backyard, page 86) has done one in Oaxaca, Mexico timed for the Day of the Dead. In fact, several of the photographers here in this book run the occasional photo workshop when it fits in with their schedule, and usually it's to places they know well, so the access groundwork will already be done for you, and by an experienced photographer no less.

Patricia Pomerleau (see Follow the Lead, page 32), has attended a few workshops herself, she explains:

'Tours do all the organizing work for you, leaving you to focus on the images you want to capture. I choose tours based on the expert photographer. If you love a photographer's work and it matches your style, the chances are that it would be a good match for you. Joining a photography tour allows you to travel alone but to be with people with whom you have a similar interest . . . Note: I ONLY go on small tours — no more than eight people. For intense photography tours, this is important.

'The only downsides would be, in some tours, a lack of flexibility to go off on your own if you discover something that you want to follow. Depending on the size of the tour group, you should be able to just go off by yourself for an afternoon — you just need to coordinate with the tour leader. I have done this many times, but you could not do this on a tour with a large group.' – *Patricia Pomerleau*

Photo workshops have boomed, for all the above reasons, and inevitably there's a big range in quality. Anyone can do it, and the promises made in online promotion are never modest. Many photographers struggle to make a living, and running a workshop has

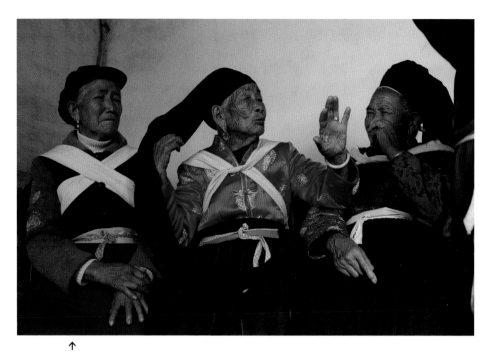

↑

Michael Freeman
Naxi centenarian at her birthday party, Yunnan, China, 2013

become a business in its own right, which usually doesn't translate into good value for you, the person attending. Things to avoid are sloppy organization, vague itineraries and photographic instruction from someone who's less talented than you are. Realize also that workshops work financially for the people running them only when a sufficient number of attendees sign up, therefore two bad things can happen. One is if they don't get enough people, in which case it will be cancelled (not good if you've bought a cheap and therefore non-refundable air ticket). The other is the temptation for them to admit more attendees than they should.

When choosing, look first for a photographer whose work you admire so that you know what style and techniques you can expect to learn, and then check out the location.

Follow the lead

Taking the photography workshop a step further, **there's an even more tightly focused version in which the professional photographer who leads has a real specialty and can offer the kind of access that would otherwise be impossible**. A remote and normally inaccessible island like St Kilda? Yes, there's just one company permitted. Chernobyl Exclusion Zone? Sure, and of course shooting digitally means no issues with fogged film. If there's a specialty area in photography, you can bet that someone will be trying their best to make it available.

NORDphotography, based in Norway, is at the high end of the business, and runs specialized workshops with small classes. One of these is with the leading Russian ballet photographer Mark Olich, in St Petersburg. Patricia Pomerleau (see Destination Workshop, page 30) attended one, because of her longstanding interest in ballet.

'My sister was a professional ballet dancer and we lived together when I was in grad school and she was at the Boston Conservatory. Because of our living close to the Conservatory, I had ballerinas draped over my sofas and chairs, always stretching, for at least two years — I know their positions intuitively. It gave me an insight into dancers' bodies and movements that really helps with photography — as well as my having photographed my Cuban National Ballet dancers for years. In ballet, like all good photography, it can't be forced. You position yourself, you wait, and then something magical happens.' – *Patricia Pomerleau*

Pomerleau was with a group of six photographers for a live performance of Swan Lake at the Hermitage Theatre. Because of Olich's reputation, ballet companies let him bring in other photographers. 'He makes you come to the theatre two hours early,' says Patricia, 'to understand the ropes and know how to stay out of the way (these were live performances) . . . We had to promise that we would give them a selection of our photos. They get great publicity photos and we get access backstage.'

↑

Patricia Pomerleau
Dancer in Red, 2019

→

Patricia Pomerleau
Von Rothbart as
Owl, 2019

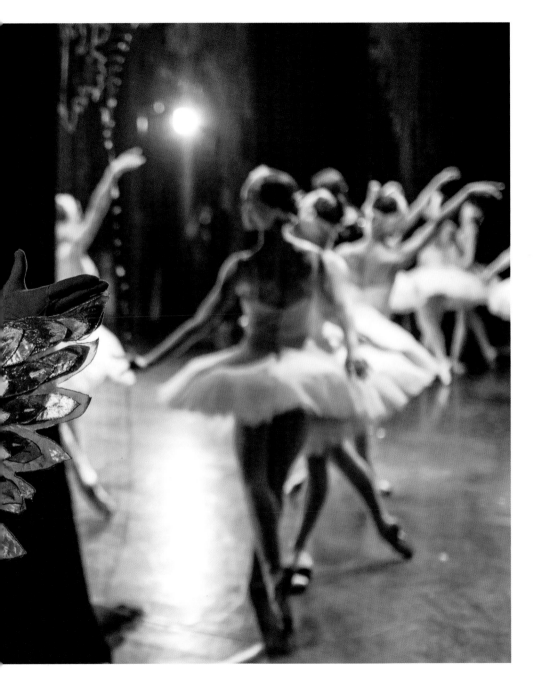

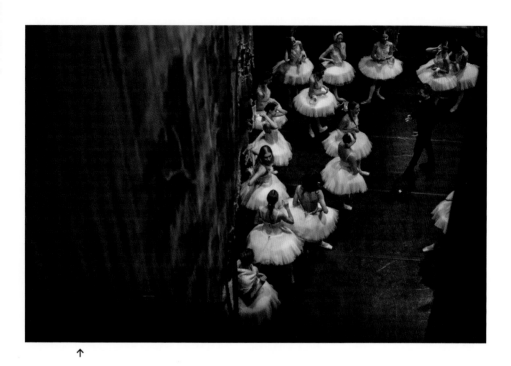

↑

Patricia Pomerleau
Swans After the Performance, 2019

Olich says about backstage photography, 'Extraordinary things happen behind the curtains. An ordinary ballerina (let's call her Masha Ivanova) can be speaking with a friend, thinking about her problems and then, taking a step forward, she stops being Ivanova and becomes the Lilac Fairy or another unearthly character.' Pomerleau takes this up, 'St Petersburg was a such a great opportunity. I shot the entire two live performances with one lens (a 35mm ƒ/1.4), as I wanted my decisions to be based on what was happening, not on camera decisions. I also had to climb up and down a steep ladder to get to the rafters, so more than one camera or even more than one lens, was just not on the cards. One needs to understand that "backstage" has many opportunities that aren't on the stage.'

The takeaway

Embrace technology:
There are apps out there (which are getting better all the time) that help you calculate the position of the sun so you can be in the right place at the right time.

Be prepared:
When things happen quickly, you'll save valuable time if you have already set your camera. While f/8 and 1/125 second were the old standbys, now you can automate and program your settings, but you still need to predict the limits, like your highest acceptable ISO and the minimum shutter speed for the action.

Always carry a camera (and yes, a smartphone IS a camera):
The most prized photographs are usually the ones you can't predict, so you need to be ready to take advantage of any opportunity.

Hearts & Minds

2 ←

People skills — that's what this chapter is all about. In one sense, it's a topic beyond the scope of this book, but unless you're doggedly committed to shooting objects that can't talk back to you, like public buildings and landscapes, you're going to have deal with people. Not everyone's comfortable with that, but there are ways to get around this, and we're going to deal with them here.

First, please be aware that there are cycles of acceptability in photographing people (and their possessions), and right now we're down in the trough of the acceptability cycle. Increasingly, people are more sensitive to becoming camera fodder. Gone are the days when a professional photographer was granted some kind of special status and permission to traipse through any culture and collection of lives to 'report and document'. We're now in an age where personal privacy is highly valued. And fair enough. As a photographer, you don't have a heaven-sent right to do as you wish. How would *you* like some complete stranger poking a machine in your face? So, **the magic word here is tact**.

In order to get effective pictures, you as a photographer want the freedom to do it your way, and that's reasonable. But the people you photograph are not under any obligation to comply. For example, I live in a small area in London with houses that are prettily painted. It's become what I call 'Instagram Village'. Tourists love to photograph themselves in front of the houses on my street, including mine. That's fine, welcome, and the valuable and interesting thing for me is that it puts me on the other side. Empathy is a really over-used word, but it's worth thinking about. **When you're about to shoot, put yourself in the other person's shoes. How would you like it? What could that photographer say to you to make you feel comfortable, even happy, willing?** Read on, please.

Home territory

There's an undeniable excitement in heading off for the unknown to explore, whether it's to an exotic location (see Destination Workshop, page 30) that you're visiting for the first time or a special one-off event. Many of us get fired up by the possibilities of the new and unfamiliar, and that itself can be an asset. However, one of the most overlooked advantages available to everyone is simply the natural familiarity we have with the places we grew up in, live or work. We take them for granted, and they just don't seem as interesting as places on the far horizon.

Well, exotic places aren't exotic to those who live in them, and by the same token, what goes on around your own territory may be absolutely idiosyncratic and fascinating to others.

Stuart Freedman, whose reportage assignments feature a significant amount of long haul travel (to Africa, India and more), tapped into his own upbringing in Dalston, East London, when he began photographing the traditional eel, pie and mash shops of the city. A collection of his images became the book *The Englishman & the Eel*. One of the symbols of cockney culture in London's East End, these establishments started to spring up in the Victorian era as cheap places to eat, offering, as Freedman writes, 'the staple diet of the London poor. Clean.

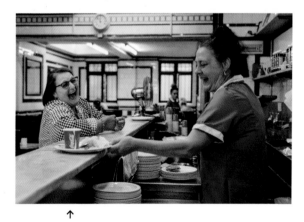

Tidy, Respectable. Victorian. White tiled walls. Sawdust on the floor. Wooden benches. Honest food, honest people.'

Times have moved on, so these places often feel like a relic of a culture as alien as anything we might hope for in far-flung locations. But for Stuart, it was about recording his own culture after

↑

Stuart Freedman
Manze's Pie and Mash shop, Tower Bridge Road, London, 2017

spending so much time away from home. Having grown up in the area, Freedman fitted in naturally; he knows the banter, when to talk and when not to, and he knows how these places function. For instance:

'People don't linger in these places: they are not intellectual salons for languid debate, rather places to eat quickly and leave . . . I had to work very quickly and be very direct. Approaching people whilst they're eating is also complicated. It's usually a very private moment and one has to be decisive in choosing the right person and situation to photograph.

'I don't have a "secret" to getting close to people; I just do my best to be friendly, explain what I'm doing and smile a lot . . . I've spent most of my long career out of the UK, mostly in places where I can't speak the language and so perhaps I've learned to be patient and polite.'
– *Stuart Freedman*

The picture opposite was taken at Manze's Pie and Mash shop on Tower Bridge Road. Freedman highlights how being familiar with your subject can lead to opportunity:

'I spent a few days there just hanging around drinking lots of tea. I was behind the counter watching the girls serve and wash up and generally getting in the way when a woman came in to order and shared a joke. A shot like this is not an accident, it's a calculation about what might happen and being in the right place. Compositionally it's very simple and shot on a 50mm lens (as was much of the book).'
– *Stuart Freedman*

In any picture story, variety drives the pace and rhythm, and details are important.

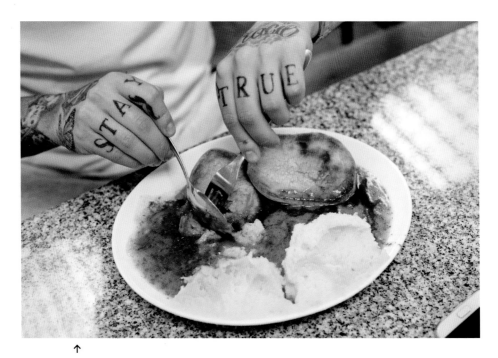

↑

Stuart Freedman
Joe and His Tattoos. Robins Pie and Mash shop,
Southend-On-Sea, Essex, 2016

'I'd noticed the tattoos on the man's hands as he'd arrived and so went over to him and explained what I was doing. I knew how important the phrase on his knuckles might be in terms of the culture of the shops and it was really then just a question of how to best frame the picture. In the book, it's the last image of the main section – a kind of ending.' – *Stuart Freedman*

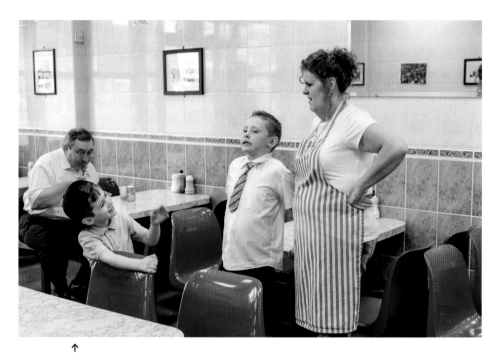

↑

Stuart Freedman
Eastenders Pie & Mash shop, Poplar, London, 2017

'Taken in Eastenders Pie & Mash shop in Poplar. I'd been working at the shop all day watching the ebb and flow of the work and the customers and, around 4pm, when school finished, this lady's grandchildren came in. They wanted to tell her about their day and I just made sure that I was well placed (again on a 50mm lens) to show that – being careful of the mirror's reflections. The picture is made by the smaller boy's movement and the elder child's expression mirrored in her face. I deliberately waited until the seated man eating his late lunch could be *seen* to be eating – to have a fork close to his mouth – otherwise, compositionally, he's superfluous.' – *Stuart Freedman*

Family life

If home territory (see Home Territory, page 40) has the clear advantage of being both familiar and accessible, then family members offer even more immediate access. And, depending on the state of family relationships, more control.

Karen Knorr made the most of this in one of her best-known series of photographs, titled *Belgravia 1979–1981*. While she was studying in London, her parents, during the dip in the property market in the mid-1970s, purchased a 25-year lease on a maisonette in Belgravia — an area that's a byword for privilege and wealth. The value of this unusual access was not lost on her, and she took advantage of suddenly inhabiting this privileged world. Knorr was well versed in the history of photography, and specifically that of this upper-class city enclave, which was famously photographed in the 1930s by Bill Brandt with more than a touch of surrealism. While she 'adored' Bill Brandt, she didn't want to follow the same path, and so, with her background in conceptual art, she decided to make a series of constructed portraits.

'The photographs are not about individuals but about a group of people and their ideas during a particular time in history. They are "non-portraits" in that they do not aim to flatter or to show the "truth" of these people. People are not named and remain anonymous.'
– *Karen Knorr*

Knorr's method was to stage a contextual portrait of her family and her neighbours who were willing participants in a form of caricature. 'The people photographed become actors and perform their identities in a collaborative fashion with me. We choose clothes together and decide which part of their homes would suit the portrait. There is a real complicity between us. They are after all "family".'

She then adds a provocative commentary in the form of a prominent caption. 'Neither text nor image illustrate each other, but create a "third meaning" to be completed by the spectator. The text slows down the viewing process as we study the text and return to re-evaluate the image in light of what we have read.' The result is a provocative mixture of documentary and commentary. As for access, Knorr scores a double.

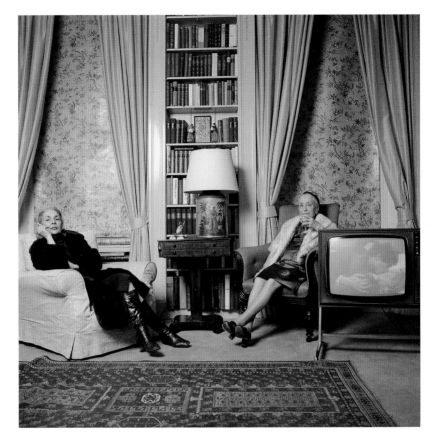

**I live in the nineteenth century
the early nineteenth century
I am fascinated by
Napoleon and Metternich
two antagonists.**

↑

Karen Knorr
From the *Belgravia* series, 1979–1981

First, by leveraging her own privilege of becoming a part of Belgravia, and second, by using an unexpected marriage of pictures and words to reveal a satirical view of this world. Her reference of a 'third meaning' echoes the famous 'third effect' first described by *Life* magazine's picture editor Wilson Hicks — the new meaning created by juxtaposing two photographs.

Be invisible

Sound like a tough challenge? It might not be as difficult as you may think, because visibility has a lot to do with who's doing the looking. **As any accomplished street photographer will tell you, there are ways of behaving and moving that render you uninteresting and part of the street furniture.**

There's a showboating style of photography that we've probably all seen, especially at big events, in which the photographer draws attention to themselves with a bit of swagger, heavy-duty equipment, a big lens or two, and usually a multi-pocket jacket. The overall aim is to say, 'Look at me, I'm the big famous guy, so don't get in my way.' I see this a lot, and apart from being psychologically suspect, it gets you absolutely nowhere in either street photography or any kind of situation where you want to capture normal life. Here, you do want to be uninteresting!

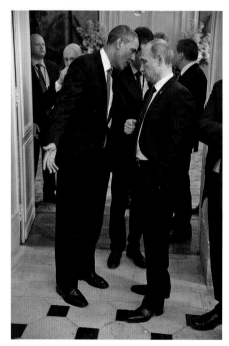

This is why it's absolutely crucial to know at the start what kind of access you need.

There's a clear difference between getting a backstage pass at a rock concert so as to gain access to a restricted area and getting access to ordinary people's unguarded moments. This may be the most misunderstood type of access a photographer needs — being allowed to shoot natural life going on around you – and there are just two ways of getting it. One of them is to become thoroughly accepted by your subjects (see Embed, page 100), the other is this: to not be noticed at all because you blend in.

Arguably the greatest photographer at this kind of shooting was Henri Cartier-Bresson. As Adrian Hamilton, a colleague of his, wrote when working on portrait assignments for *Vogue*, 'Most of the subjects were surprised that he didn't ask them to sit or stand this way or that. "Just talk to Adrian," he'd say . . . "I'll just stay in the background." Which is what he did, almost invisible . . . '

Here are seven ways of deflecting attention away from yourself, and you'll see that they're a mixture of appearance and behaviour:

→ Dress in discreet clothing
→ Keep the camera out of sight
→ Move around the margins, not in the middle
→ Either keep moving or sit down
→ Bring a friend with you, take pictures of them
→ Do what other people are doing
→ Don't make unnecessary eye contact

These do work – they've been proven professionally! Take the image opposite captured by Pete Souza, who was able to get so close to the two statesmen that he could her them speaking. Souza recalls:

'I was within earshot. I can't recount specifically what they said, but I knew the subject matter . . . This conversation went on for a while: they weren't thinking about me. To them, I was just one of many people in the room, coming and going in different directions. I started out shooting horizontally and tighter, and then switched to vertical, backing up to show their entire bodies. Compositionally, that seemed to show the body language better.' – *Pete Souza*

←

Pete Souza
Barack Obama talks with Russian President
Vladimir Putin after a lunch commemorating
the 70th anniversary of D-Day in Normandy,
France, June 6, 2014

Undercover

When you know in advance that a situation forbids photography, you first need to have a very good reason to flout authority, and then you need to plan how to shoot surreptitiously. This is the serious end of investigative photojournalism, and while you're not likely to be facing the same challenges as Hazel Thompson, there are plenty of valuable lessons to be learned from her remarkable shoot of kids locked up in adult Philippine prisons.

Thompson has form documenting global social abuse stories, but this was one of the toughest. It began when an NGO asked for picture research on minors being illegally locked up with adults in prisons around the world, with a view to making a global report to present to the UN. Her research revealed that there were hardly any pictures to offer as evidence, and that's when and why it was suggested as a subject for a photo story. This led her to the Jubilee Campaign who work in partnership with Father Shay Cullen, who has a team of volunteers who visit prisons in Manila and other cities to act as advocates for children who've become stuck in the system.

Thompson decided that the best way to gain access was to go in disguised as a Western social worker and join them on their routine circuits. The challenge was to get a camera past high security. 'We knew that if I got caught I'd be charged and would likely be imprisoned.'

'I took my smallest camera, which was a film camera, and broke it down into body and lens, to put at the bottom of a small bag. I added a few makeup items so it just looked like a really girly handbag, but the key turned out to be sanitary towels on top! Another key piece of equipment was a light scarf, because if you're in a situation you can cover your head or cover the camera, or put [it] over the bag while you're trying to get something out. I put [the films] in my underwear and bra, as I was told that you don't usually get body-searched, because often there weren't any female officers to do that.'
– Hazel Thompson

Thompson and the team managed four prisons in Metro Manila in two days. 'The first prison, Novatus, was incredibly nerve-wracking. Could I

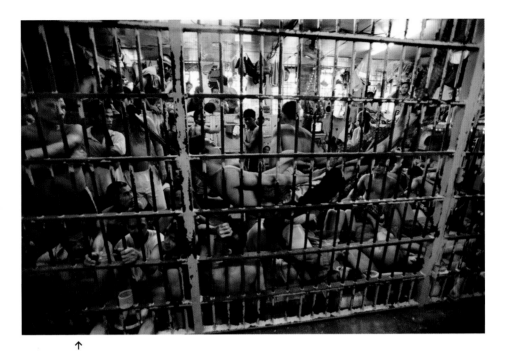

↑

Hazel Thompson
The overcrowded cells in a jail in Metro Manila, 2005

get in? Could I sneak in the camera? . . . yes, they looked inside the bag, saw the sanitary towels, and it worked.' Nothing, however, had prepared Thompson for what she saw inside.

'There was flooding on the floor . . . It was incredibly noisy, incredibly hot, zero ventilation, and the intense smell of bodies, sweat, sewage . . . It wasn't a pleasant space. And next the shock of what I was seeing: packed cells on the left and right, cage after cage going up the whole length of the corridor, all packed full. It was a horrific sight, something I wouldn't expect to see in this day and age, something from medieval times.' – *Hazel Thompson*

The shot above was very hard to get, because Thompson and the other aid workers were being escorted all the time by guards. It was one of 10 cells along a corridor.

↑

Hazel Thompson
A jail in Metro Manila. The jail consists of a very small cell,
measuring 1 × 5m at the end of a room. Currently 13 people are
imprisoned in this inhumane space, 2005

'I pretended that I needed to get something from back inside the prison cell . . . I communicated a little with the prison officer there who was distracted and then ignored me. I turned, I decided in advance at which point I would stop — where the most light was — and walked, my hands around the camera under the scarf in my bag. I stopped, took a few frames and walked on again.' – *Hazel Thompson*

Thompson nearly missed out on her next picture (above), as initially no one realized there was a cell there. 'We found 13 individuals in that tiny prison cell that day: 11 adults and 2 children. It was shocking. The boy you see at the front was clearly in a bad mental state . . . I was grateful that the light from the television lit up the boy's face enough to be able to see him clearly.'

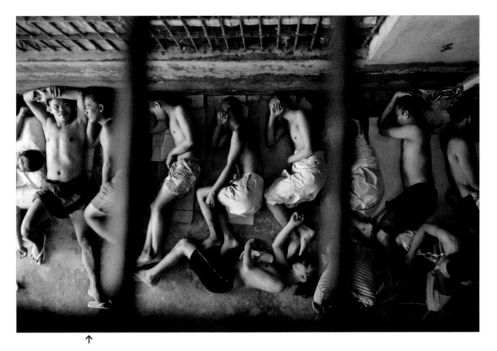

↑

Hazel Thompson
Prisoners sleeping on the floor in a jail
in Metro Manila, 2005

The third picture (above) looks down into a concrete cell from the floor above. Getting the camera into position meant Thompson had to lean far over, and at the moment when the aid workers said 'yes, it's all clear, you can take the photograph,' one of them held on to her belt and legs. 'As I lent with my full weight forward, one of the guys below opened his eyes and that's the guy on the left looking straight up at me.'

Thompson is at pains to stress that this was all a team effort. 'I couldn't, I didn't, work alone. I had a whole team of social workers and advocates behind me who were passionate for change in their country. If it wasn't for them willing to take this risk, I wouldn't have got this evidence.'

Straight talk

William Albert Allard was one of the *National Geographic*'s most respected photographers, with what became a special affection for rural life. The shoot that gave him his break was a story on the Amish, who famously resist photography because it's seen as a temptation to vanity (and this was way before selfies became a thing) and also because this closed community, with their traditional farming ways, doesn't like being treated as an object of curiosity. Who does? The result is that almost all published photographs of the Amish are telephoto or sneakily caught. Except for Allard's, shot in 1964, when he had been given a summer job as an intern at *National Geographic*.

'Bob Gilka [the magazine's Director of Photography] said, "Go to this Cookstown, Pennsylvania, Dutch Festival for the weekend, and if you can, see if you can get some pictures of some Amish." . . . I found out later that the staff photographer went to the Amish bishop, who of course said no – that's what bishops are going to do.

'I just started driving the roads, introducing myself to Amish people, in the same way I do now. I just said who I am, who I represented and what I wanted to do and why I thought we should do it. And that story, which ended up being published the next summer with the lead picture of a very simple portrait of an Amish boy holding a little guinea pig, which he insisted he wanted to show me, his pet, at the end of the afternoon one day, that just kind of jumpstarted my career.' – *William Albert Allard*

Part of Allard's charm is his directness and his honesty. He's not known to beat around the bush. 'I've always felt that the best way to approach a subject or people that you want to work with is the most direct way,' he says. 'There is no formula. Hopefully, you don't have too low a rejection threshold because there are people who aren't going to want you to do that. But you don't need a doctorate in psychology to see if you're irritating someone. I also get asked, "Do you go up and ask for permission?" If I do that, I've just chased the subject away,' as would have certainly happened with the Amish.

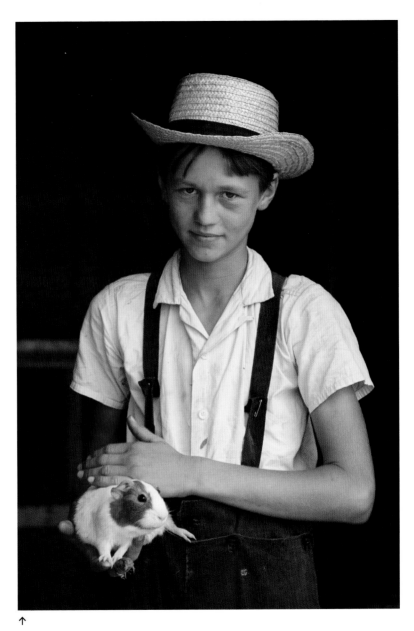

↑

William Albert Allard
Amish boy with pet guinea pig, 1964

↑

William Albert Allard
A young Amish girl holds the reins of two huge draft horses,
1964

Being a stranger in town with a camera requires a special balance of restraint and directness. 'Sometimes it's every bit as important for the subject to get to know you as it is for you to get to know the subject, for them to be comfortable with you.' Allard avoids asking permission formally and in advance because of what can happen (see The Permission Avenue, page 56). Instead, he explains on the spot and in a frank manner. He relies on showing, by his actions, interest and straight talking, that he's a regular guy on the same level as the people he wants to photograph, rather than presenting himself apart from them as a career photographer.

'I tell photographers there's something very important in documentary photography, especially if you're on your own, and that's access. But there's one thing that's even more important and that's acceptance. [See Embed, page 100.] Once you have acceptance, they start giving you the pictures. My best pictures were given to me. I didn't really take them.' – *William Albert Allard*

Allard and his Amish story were widely credited with changing the direction in which the magazine evolved — no mean feat for a single photographer at the very beginning of his career.

'It wasn't due to any genius on my part. I think the key word is simply intimacy. People in the sixties were not used to seeing this in the *National Geographic* magazine. My story came out, and here was a very simple photograph of a young boy. It was very direct.' – *William Albert Allard*

The permission avenue

Yes, it's not just a way or a route, it's an *avenue*. This is a basic reportage photographer's dilemma: **If you're granted permission, from anyone, whether a stallholder in a picturesque market or the commander of a naval base, then it's all plain sailing. But if you're refused, that's it.** You've closed off any alternatives, any sideways approaches or backdoor entrances. If you are asking to take a portrait of someone you've only just seen in the street, then you have to use your judgement, and it had better be good. You could perhaps try the invisibility method (see Be Invisible, page 46), and go for it quickly. Or you might decide that the only way to do it properly will require at least a bit of co-operation, and so you will need to ask. That's what happened in the shot of the Tibetan man opposite. He had such a strong face that I really wanted to take his portrait.

I was in northern Yunnan, which is ethnically Tibetan, and shooting around the area of the upper Yangtze with the help of a French woman, Estelle Chard, who lives in one of the villages (see The Bridger, page 72). She had forged good relations with her neighbours and, knowing my interest in the Tea Horse Road, about which I published a book, she suggested we visit the house where generations of caravan leaders had lived. Tea Horse Road was one of the longest trade routes in the ancient world, and Benzilan, a trading post in the gorge of the Yangtze, was famous for the calibre of its muleteers, called *Lado* in Tibetan.

It was a tough business, and this man was the last in his family to have seen it. The only problem was that he didn't take kindly to everyone, so there was a good chance he would refuse a picture. With this in mind, we timed our visit for when his son, who could translate for us, was there. We were introduced and shown around the old family house, with its prayer room and traditional furniture, none of which was as interesting as the man. Anticipating that I would need to be quick if given permission to shoot, I looked for a good setting with good lighting. Having had a quite friendly conversation for about quarter of an hour, I judged the time was right to ask, through his son, if I could take his portrait. He agreed, I asked him to please stand in the position I'd chosen, and a I shot a few frames very quickly.

↑

Michael Freeman
Tibetan muleteer, Yunnan, China, 2015

Ask forgiveness

'In China, much of life involves skirting regulations, and one of the basic truths is that forgiveness comes easier than permission.' — Peter Hessler, *Country Driving: A Journey Through China from Farm to Factory.*

The all-embracing chain of command that has managed every aspect of Chinese life for 70 years has made sure that the many, many locals do what they're told to do, and personal initiative is frowned on. At the same time, this jars with normal community relations where people generally have to get along. The problem with permission (see The Permission Avenue, page 56) is that it means approval, and that sets a precedent, whereas simply quietly letting someone get away with doing what would have been refused doesn't signify approval. This is highly relevant if you're shooting in a situation where you know the rules are going to stop you — or at least have a suspicion that they might.

And this isn't about China, incidentally. **The permission–forgiveness trade-off is one to consider everywhere.** It doesn't always work. There are some transgressions that will get you into serious trouble. If you see a sign that says something like 'military area, do not use a camera,' don't push your luck. But if the sign says 'no tripods,' or worse still 'apply to the Archaeological Survey of India 15 days in advance for permission to use a tripod,' you might try your luck. Don't take this as an encouragement for breaking the law, but the reality of being a photographer is that you do come up against restrictions that may seem petty and pointless. Objectively they may even BE petty and pointless, but in any case, your decision revolves around whether you're going to try and get away with it.

Here are two examples. The first is in Kolkata (formerly known as Calcutta), which used to be a byword for abject urban poverty and squalor. While some of the city has smartened up significantly, there's still a large part that's unreconstructed. The area by the Hooghly River (see overleaf) is one of those, but it's also home to the wonderful

Howrah Bridge, built by the British during the last war. This is not just any bridge, as you can see, but a unique construction, like a giant Meccano set, and its location in this grimy, muddy and misty setting make it irresistible. Strange, then, that under Indian law it's illegal to photograph — as are all bridges in India.

With mobile phones ubiquitous, it's pretty much impossible to stop casual photography anywhere, but a real camera still attracts attention. So the only sensible approach is to keep the camera in a bag, find your viewpoint, pull it out and shoot without delay. After which just be prepared to say sorry. **Actually, if you expect to have to make apologies to someone in authority, also make sure you save a copy of the image.** In the old days of film (the photograph overleaf was shot on Kodachrome), if there wasn't too much unexposed film left on the roll, you just rewound it, popped it in a pocket and put in a new roll. Nowadays, you can use your camera's built-in Wi-Fi to send the picture to your phone.

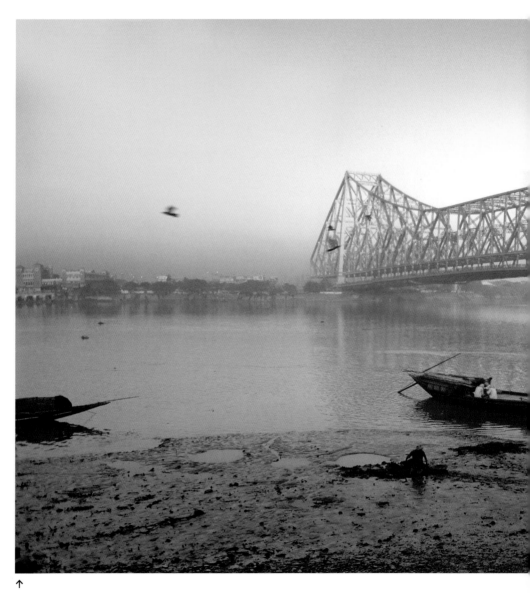

↑

Michael Freeman

Howrah Bridge, Kolkata, India, 1976

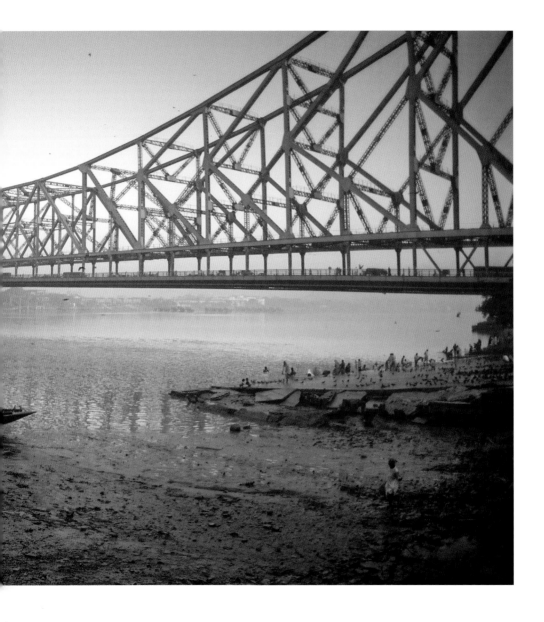

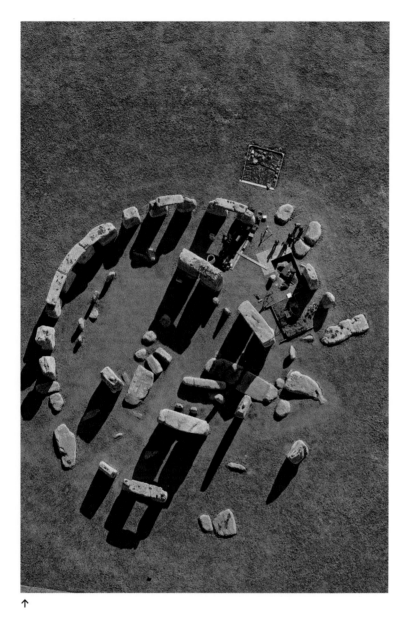

↑

Michael Freeman
Stonehenge from the air, Stonehenge, Wiltshire, 2008

Case study number two is Stonehenge: England's top tourist attraction, which sees 1.5 million visitors a year. Managed strictly by English Heritage, there are very definitely restrictions on access. I had a story to shoot for the *Smithsonian* magazine on an archaeological dig at the site — the first in almost half a century. That meant going down the permissions route, as we needed access to the dig inside the stone circle, and we were closely linked to a television channel. That part was fine, if a little tedious. But Stonehenge is a circle, right? Circles look striking from above, very graphic, and high on the shooting script was an aerial shot. Here though, English Heritage have very clear rules, chief among them, that you're not allowed to fly overhead, in case something were to fall onto the monument, like a helicopter. If you think sneaking a drone over is the obvious answer, think again — it counts the same as a helicopter.

There were two other wrinkles. First, Stonehenge is surrounded by military airspace, and while it's used only occasionally, it can be blocked to civilian use without notice. Second, English spring weather is not known for its predictability, and Stonehenge from the air definitely benefits from sharp raking sunlight. In the end, I took my chances and booked a slot with the local helicopter company and when they called to tell me a cold front was on the way and we'd better get it done before that arrived, I jumped in the car, rushed to the airfield and we were soon circling the stones. But, how to deal with not being allowed directly overhead?

Chat with the pilot, enlist sympathy, sigh once or twice about how much greater it would be if only, just a little closer perhaps, oh almost perfect . . . We briefly drifted in a line to carry us right over, I couldn't see anyone shaking their fist at the sky, so I established my frame and that was that. Notice that I off-centred the circle in the bottom of the frame for the simple reason that this could be a cover shot, and there needs to be room for the masthead. I was back the next day at the site, primed to apologize, but it passed over without comment.

Make a connection

Special access to events and occasions that are either off the public radar (see Follow the Lead, page 32) or are heavily subscribed usually means invoking some kind of privilege. That's a word and an idea that rankles with many people, because it sounds unfair and a bit like queue-jumping, but in reality, it is the way that things work at all levels. We have our networks of friends, for instance, for whom we go out of our way to help with things, and they us.

Tapping in somehow to a wider network is one of the most effective ways of opening doors to restricted areas or things that are difficult to photograph. The practical issue is how to tap in to new networks.

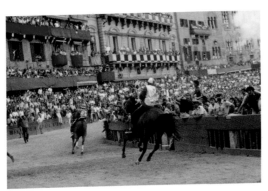

Here are two examples, from different cultures, both on-the-spot efforts. In the first, I was shooting for a book on Tuscany and was in the area of Siena at the time of the annual Palio, a no-holds-barred horse race dating back to the Middle Ages in which jockeys ride without saddles and there are few rules. One thing to understand about the Sienese is that the Palio is their own private city race, not a tourist spectacle. In fact, it's more like a battle between the *contrade* (the city's wards), and the rivalry is intense. Now, say you're a television crew from Rome? Go and find your own viewpoint!

So, how can you get a good camera position? Enter Lorenza de' Medici, Italian television personality with a wine estate close to the city, and with very powerful local connections. She was the author of the book on Tuscan cooking for which I was taking the photographs. Front row seats at the Palio are more like gold bars than gold dust, but with Lorenza on the case one of them fell my way. Even more special was our invitation to the open-air contrada dinner afterward. That's a connection in action.

← ↑

Michael Freeman
Palio, Siena, Italy, 1991

A second example is from China. I was leading a photography work-shop (see Destination Workshop, page 30) in the small town of Shuhe in Yunnan. This area, around Lijiang and the high peaks of Jade Dragon Mountain, is fascinating for its mix of ethnic communities, from the Naxi in the valleys to more isolated groups in the highlands, and Lijiang itself is a popular tourist destination. I've been running workshops with friends who have an adventure lodge called The Bivou offering a programme of events including climbing, hiking, photography and so on. One of the partners has spent much time cultivating the friendship of the local Yi community, who have villages high on Jade Dragon Mountain, and who normally stay apart from the touristy life below in the valley. Her main contact, a Yi teacher who visits the town regularly, mentioned that there was soon to be a large and traditional funeral for an elder. Over a couple of days, we gently negotiated to be able to attend. This was a great privilege, and needless to say there was no one else from outside this ethnic community apart from our small group. Many Yi from surrounding communities would attend; it would be colourful and fascinating.

Before we entered the village, I advised my group that despite the great temptation to start shooting, it would be better to keep cameras packed away for a while and simply attend as visitors, be introduced to the family and leaders, sit and take tea (see Embed, page 100). Once these polite formalities had been seen to, we would be able to take pictures to our hearts' content. And that is what happened.

The takeaway from these two examples is the benefit of finding the best and closest connection you can. Do you know anyone who has a direct line to the action? No? Then how about someone who knows someone. Two degrees of separation is often do-able, but you do need to think clearly about who has the ability to facilitate, because reaching them is your ultimate goal.

↑
Michael Freeman
Yi funeral, Yunnan, China, 2013

Diplomatic channels

In all of the entries within this book, I'm trying to end with a practical take-away, so that even if the particular example is exotic, you can apply it to a situation that you personally have to deal with. This one may be different and less obviously accessible as **it involves higher-level connections. But please don't be put off. They can, sometimes and surprisingly, come your way.** Never let them pass.

Sudan was a country I had never thought about photographing. There was no aversion; it just hadn't come into my line of sight. That was until two of my oldest friends, who had very strong relationships with Sudan, proposed a book on the country and its people.

I first met Vicki Butler when she was the *Time* stringer in Bangkok, deputed to look after the very green English photographer about to arrive. She and her soon-to-be-husband and outstanding field diplomat Tim Carney became my lifelong friends. Fast forward 30 years and the two of them brought up the idea of a book on Sudan, the reason being that Tim, who was the last US ambassador there and had just

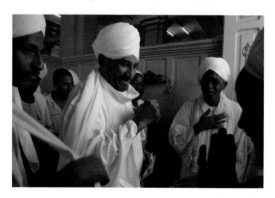

retired, had unfinished business. He had deeply disagreed with the State Department's policy there (another story, but you could look up a *Vanity Fair* interview from January 2002). Now that he was free to disagree, he wanted to show Sudan, still on the US blacklist as a 'state sponsor of terrorism' for what it was and is — a nation of people with, as he put it, the same hopes, fears and ambitions as anyone else in the world. So this was a project to counter the demonizing of a people alongside an admittedly not-great government. Long-form photojournalism seemed the best approach, because it takes time and a lot of pictures to get such a message across. Soundbite journalism simplifies subjects beyond reason.

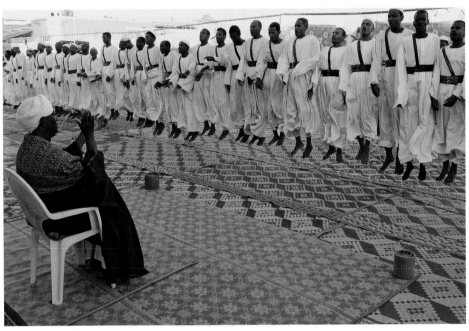

↑

Michael Freeman
Sadiq Al Mahdi at Friday prayers, Omdurman, Sudan 2003

←

Michael Freeman
Zikr (Sufi prayers), Omdurman, Sudan 2003

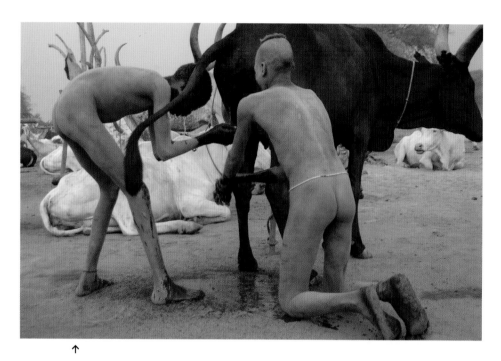

↑

Michael Freeman
Mandari boys taking a urine bath, South Sudan, 2004

In Tim's memorable words, which we ended up using many times in the country when explaining ourselves, the idea was 'to complicate people's minds' about Sudan. I still love that expression; it sums up everything that photographers and journalists should do.

My first reaction was to ask 'Can we do this, can we do that, can we get here?' to which the answer was an immediate yes, because Tim had secured the approval of the vice president in Khartoum as well as the leader of the opposition in the south of Sudan. The book, while just a book, became one of the very few cross-border projects in the divided country.

The essential difference between this approach and others in this chapter is that the connection is made at a high level, and the request for assistance is then handed down. I won't pretend that this is easy, but it's often worth a go, even if you have to write formally to someone. For instance, an often-overlooked route is through the cultural attaché at an embassy. Their interests may well coincide with yours, as long as what you want to do will produce imagery that they can use positively. But if you're intending to do investigative photography like Hazel Thompson (see Undercover, page 48), then diplomatic channels are something to avoid!

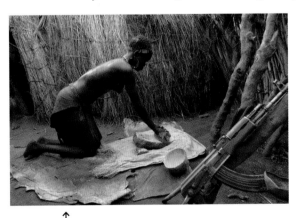

↑

Michael Freeman
Jie girl grinding Sorghum, Southeast Sudan, 2004

The bridger

To gain fast-track entry into any community that you're not a part of you need to find a very particular kind of person. Someone who's part of that community but also — and this is the special bit — has a presence outside it. **Ideally, you need to find someone with a foot in that world and a foot in yours. I call them 'bridgers' because they allow you to cross that gap.**

A case in point was a shoot in the Maldives for a resort client, yet it was not a strictly commercial assignment. The client was forward-looking and imaginative, and what they wanted was decidedly not a book promoting the amenities and views of the resort itself, but one that showed instead actual local life. Seventy percent of the Maldives GDP comes from tourism and that's part of the story. They wanted a photobook about the country and its people.

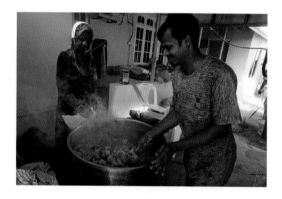

But with more than two-thirds of the Maldives concentrating on tourism, most of the many small islands are resorts — there's one per island. So we had to go to nearby 'local islands', as we called them. Logistically this was no problem — it simply meant a speedboat for no more than half an hour — and the Maldivians are typically friendly and laid-back. The issue, however, was getting access in just a few hours to genuinely natural life going on around you, especially given that in a community of say a hundred people who live together all the time, an outsider photographer sort of stands out. **Being a fly on the wall wasn't possible, but being accepted might be.**

On some of these local islands close to the resort islands, there's already a system for showing tourists around for a couple of hours and introducing them to local customs and crafts. This, unsurprisingly, involves setting up little displays, which is as far as you could imagine from natural.

↑

Michael Freeman
Café, Dhidhdhoo Island, Maldives 2019

←

Michael Freeman
Cooking for a communal Muslim meal, Dhidhdhoo Island,
Maldives, 2019

There was also an extra, slight layer of complication in that Maldives society is Islamic — something you wouldn't even notice as a tourist. It does, however, add a little conservatism into the mix that would make you think twice about brusquely poking your camera into every corner of local life (which you shouldn't do anyway, but photographers do tend to get carried away with getting the shot).

The solution was (and is generally) twofold: it involved getting access

to a smaller community that didn't receive visitors much and someone who was a part of it to make the introductions (see Join the Cause, page 92). Adam, who was one of the more senior people working for the company in the capital, Malé, took me to the small island of Dhidhdhoo, where both his parents lived. And really, it was as simple as that.

Adam knew everyone there, the atmosphere was relaxed in that small-community way, and I was able to slot in like a family guest. Very quickly, everyone forgot the novelty of the camera and got back to normal life, which included a kind of thanksgiving lunch for the community following Friday prayers at the little mosque. Adam was my bridger, and I was able to shoot more in one morning than I would expect to in a week without this deep introduction.

↑

Michael Freeman
Net fishing, Dhidhdhoo Island, Maldives, 2019

→

Michael Freeman
Communal Muslim meal, Dhidhdhoo Island, Maldives, 2019

The takeaway

Home is where the heart is:
We're all excited by the exotic, and there's an allure to far-off locations, but don't neglect the deeper knowledge and entry you already have of your immediate surroundings. You can use that knowledge for better access.

The quiet observer:
When it comes to candid shooting, you can stalk your subjects, or you can sit quietly in one place and let the action come to you.

Share your pictures:
It depends on the situation, but a usefully disarming technique when photographing strangers is to show them what you take. You can also offer them digital copies.

Immersion

3 ←

How deep are you prepared to go? That's the fundamental question to ask yourself when it comes to what are probably the most guaranteed set of access methods in photography.

These methods are all about getting involved so that you're not thought of and treated like a photographer. Not that there's anything wrong with having the status of a photographer, but it puts us behind a camera and that essentially places a piece of equipment between you and the subject. You could argue that it's the piece of equipment that connects you to your subject, but when other people are on the other side of it, it's usually something to downplay.

Many of the access methods described in the first two chapters belong to photojournalism. It requires fast reactions, the ability to pull something good out of a new situation at a moment's notice. However, you aren't afforded time — time to reflect and explore, and more importantly, to discover things that simply aren't always visible immediately. The great Iranian Magnum photographer Abbas wrote:

'. . . these days I don't call myself a photojournalist because, although I use the techniques of a photojournalist and get published in magazines and newspapers, I am working at things in depth and over long periods of time. I don't just make stories about what's happening. I'm making stories about my way of seeing what's happening.'

To tell stories through immersion you need three things:
→ Commitment — you must devote time to your subject
→ Trust — to be built up based on the way you behave
→ Observation skills — you must spend time NOT shooting

Does that sound strange? A camera is invasive, it's a cold piece of machinery. Aimed at a person it's like pointing a finger, but worse, it prevents normal and necessary eye contact. **By immersing yourself, you're choosing to spend time with your subject, and a wise way of spending some of that at the start is to keep the camera down.**

Obsession

Big subjects require big commitment, and a classic subject for a long-form photo story is a city. There have been many, from Ernst Haas's groundbreaking two-part picture story on New York for *Life* magazine to an entire series of Time-Life Books called *Great Cities of the World*. None, however, has been more intense and more dedicated than W. Eugene Smith's marathon coverage of Pittsburgh. He had just joined Magnum and was offered a job to make about a hundred prints for a chapter in a deluxe book on the city by a well-known editor and journalist, Stefan Lorant. It was a perfect photographic assignment, and Smith became so absorbed by it that he turned it into something bigger.

The two-week assignment turned into what he called his 'long poem' to the city, beginning with a six-month stay in 1955, and not ending until late in 1957. It consumed most of his time for two years, during which he shot 17,000 negatives, all of which he processed himself. He then spent another two years printing the photographs, designing the layouts and writing. He made 7,000 5 × 7-inch proof prints from which to select and hone the final story. **Smith was known for his in-depth research and preparation, and for wrestling with core concepts for his photo stories, and Pittsburgh was no exception.** This was to be a full and diverse portrait of a city as a 'living entity', with a sub-theme being the relationship between industry and man. While Lorant wanted a book that would celebrate the recent transformation of the old 'smoky city' into 'one of the most beautiful cities in America', Smith was no fan of the capitalist-industrialist system, and paid more attention to labour and ordinary people, showing them as workers rather than as individuals. Ultimately, the city of Pittsburgh, he wrote, 'is the individual to be known.'

The image opposite was the one he chose to open the photo essay, he said, 'I wanted to show that the worker was fairly well submerged beneath the weight of industry; the anonymity of the worker's goggles and factory behind him told the story. Still, I did not want the worker to be entirely lost as a human being.'

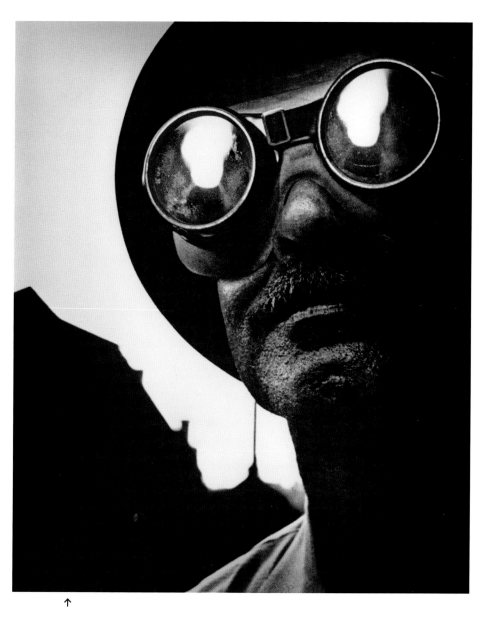

↑
W. Eugene Smith
Steelworker, Pittsburgh, Pennsylvania, USA, 1955

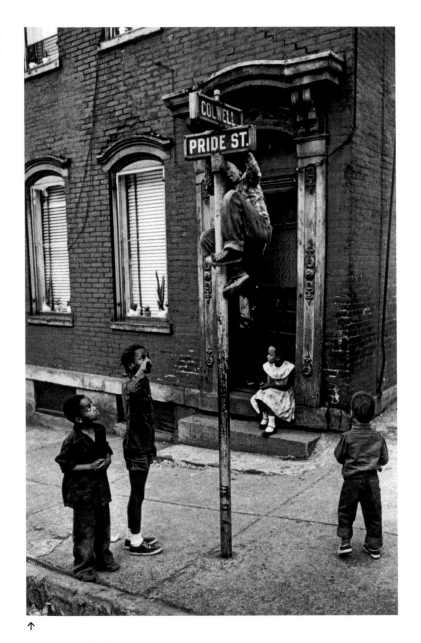

↑

W. Eugene Smith
Pittsburgh, Pennsylvania, USA, 1955

Smith and Lorant were on a collision course from the beginning over the theme for the photo essay, and on top of that, Smith's perfectionism and his ambition to push the boundaries of photo stories in general made him reluctant to let go and simply deliver the prints. Even eight months after finishing, he still hadn't handed over any prints to Lorant, who then threatened to sue both him and Magnum. It did not end well.

If ever there were a candidate for tortured genius of photography, it was Smith. Brilliant, obsessive and unreasonable, he was admired greatly for his work, but eventually all the magazines and editors of the day found it impossible to work with him. By the time of *Pittsburgh*, he had already resigned from *Life* magazine over what he thought was a botched layout of his photographs on *Man of Mercy*, his story on Nobel prizewinner Albert Schweitzer. Indeed, *Pittsburgh* in Smith's mind was to be a kind of revenge on *Life*.

Many magazines wanted the Pittsburgh story, but they all turned it down because Smith demanded that the presentation had to be satisfactory to him. This virtually meant that it was by Smith himself. In the end, it appeared in *Popular Photography*'s 1959 annual. As the editors wrote, 'What you see in these pages — expanded now to 38 — is all W. Eugene Smith, pictures, layout and text.' They gave him a good show, but for such a big story to appear only in an amateur photography magazine's annual was a comedown, to say the least.

Obsession, then, is a mixed blessing. It will certainly help you make an intense and complex photo story, but its drawback is itself. **If you're going to obsessively dig into a story and you want it to be a success all round, make sure you have a way to call halt.**

The outsider

Sometimes, and especially when there is no practical possibility of blending into a situation or society, being an outsider can actually work to your advantage. That is what German photographer Amos Schliack found in Mea Shearim, the ultra orthodox Jewish community in Jerusalem. He explains:

'To gain access to a seclusive world such as Mea Shearim isn't easy, it needs a certain degree of obsession that reaches beyond photography. Certainly it's not a place one can simply just intrude into and start shooting. It happened to me, that only after being interviewed about who I was and where I came from, people would allow me in and to take photos. Curiously enough, not being Jewish helped, because only for a Gentile — a non-Jewish person — it would have been permitted to take pictures at certain occasions like holidays, whereas a Jew would not have been allowed to do so at all.' – *Amos Schliack*

Schliack's love affair with Jerusalem began more than a half century ago, as a teenager when his father was working on a research project with a team from Hadassah University Hospital. 'The Six Day War was just over and the city was in a state of euphoria for being reunited. Coming from the divided city of Berlin, I could feel the relief.' Ten years later, when he began working for *GEO* and other magazines, he had the chance to return to Jerusalem.

'I very soon realized that just scratching the surface wouldn't do; Jerusalem doesn't allow quickies. Whenever my schedule would allow, I went exploring the narrow streets and the backyards of Mea Shearim — the Hebrew word for One Hundred Gates — and the hidden and secluded world of the Orthodox Jews living their life in their very own world according to the rules of the Torah. I got addicted and obsessed. Mea Shearim is not a place easily accessible for outsiders, and certainly not for photographers.' – *Amos Schliack*

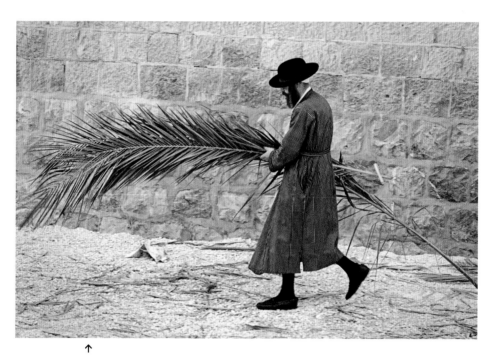

↑

Amos Schliack
Sukkot, the Feast of Tabernacle, Mea Shearim, 1978

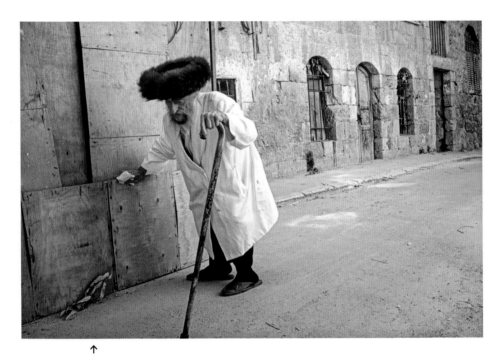

↑

Amos Schliack
Yom Kippur, Mea Shearim, 1978

Schliack's approach was to be respectful without trying to conceal the camera. 'Smile, be polite and don't be pushy. Take your pictures with respect and try not to intrude into the dignity of your subjects. Build trust. Try to blend in and become invisible, but not in the sense that you're trying to hide yourself or what you are doing.' Isaac Bashevis Singer's *The Penitent* left a 'deep impression' on Schliack and it informed the theme of his work. 'The solitude of people who had chosen to live a religious life apart from the currents of time became my subject.'

The photograph of the man carrying a palm frond (page 83) was the result of a combination of foreknowledge and luck. For the Sukkot holiday, the Feast of the Tabernacle, palm fronds are sold in the very early mornings for the days preceding — they are used to cover the booths where families eat their meals and sleep throughout the holiday. Schliack says:

'As many things, events, ceremonies etc., only happen once in a year, it is crucial to obtain a certain amount of knowledge about the whats and whens and wheres in order to capture the right moment . . . We had just arrived when this man walked across. It all happened very fast and there was not even a chance for me to do any adjustments to my camera. As a matter of fact, I didn't even look through the viewfinder — it was just a matter of press and pray. We actually talked later, and I did introduce myself, but had I attempted to talk beforehand, certainly I would not have had a chance to take this picture.' – Amos Schliack

Similarly, the picture of the other lone figure shown opposite was taken on the holiday between Rosh Hashanah, the Jewish New Year, and Yom Kippur. The kittel (white gown) is traditional for high holidays and for funerals.

Backyard

Often, what's most overlooked as a subject is what's right in front of you in your own backyard (see Home Territory, page 40). Maybe not your actual backyard, but the immediate surroundings of where you live. When thinking up new projects, we tend to concentrate on what's over the horizon and we forget to consider what's in front of us. Familiarity breeds contempt, and so on. Even when there doesn't appear to be much to shoot, there always is. A prime example of this is the Outer Banks of North Carolina, a 320-km (200-mile) string of sand spits and low, narrow barrier islands constantly shifting, growing and eroding. This region is home to veteran *National Geographic* and Magnum photographer David Alan Harvey, and when he's not on assignment, he shoots here every day.

'I live in an old cottage, made only for summer vacations in the 1920s . . . right across the street is a state park. You might find an arrowhead. The indigenous spirits are in those dunes. I feel it all the time. It's comforting because I'm at peace with those who lived on this land

↑

David Alan Harvey
Outer Banks, 2012

and in this house before me. A sharing. One of my sons, his wife, and my granddaughter live two houses down . . . When traveling, I'm often in spectacular places, yet no matter where I am my mind will drift back to right here. I guess that's what home means. We can all appreciate the planet from wherever we are at the moment.' – *David Alan Harvey*

The Outer Banks, often abbreviated to OBX, are geologically unstable, exposed to raw Atlantic weather in the form of storms and hurricanes; they don't invoke a sense of permanence. Harvey says, 'OBX is precarious living if you are the type who worries about hurricanes and nor'easters [storms] chewing at your land (sand). I'm a wind-weather sea-bleak-gray blazing-sun cold-beer-on-a-hot-beach moon-over-the-marsh log-on-the-fire sort. So I'm here and taking some pictures everywhere all the time.'

At first glance the Outer Banks seem lacking in features, other than a lot of shifting sand, but that suits Harvey, who has a natural talent for finding pictures wherever. 'When I get up at dawn, daily, I head for bike or truck to go shoot something new . . . I'm sure a shrink would say that I've used photography as excuse for escaping reality . . . probably . . . but it's too late now.' He not only shoots daily — anything and everything, including neighbours, surfers, reclamation, waves, dunes — but posts constantly. His Instagram feed is a testament to how much picture material there is in the seemingly simplest of environments.

Moreover, **the idea of exploring your backyard is exportable**. Harvey recalls, 'Everything became my backyard. I remember one trip in particular, I went to Sumatra, leaving my wife and kids behind in my suburban neighborhood [pre-OBX]. I arrived in Sumatra, and I said to a person there, "I'm here to do a story." I remember he said, "Well, what the hell are you doing here? This is a nowhere, this is just another small town." I heard that a lot. Every place is someone's backyard. This was a small fishing village under a few palm trees and there was nothing there of interest as far as they were concerned, and yet it was my topic for *National Geographic*.'

→
David Alan Harvey
Nags Head, North Carolina.
Beach dog runs, 2008

Long-term commitment

Whereas David Alan Harvey's ongoing project is to explore the unexpected possibilities around his own home (see Backyard, page 86), Peter Turnley has been obsessed with chronicling his adopted home for 40 years, Paris. In part, his affection for the city stems from the fact it has played host for centuries to artists from all genres. His photo book, called *French Kiss — A Love to Letter to Paris*, is a particularly tender view of the city. Turnley has covered many of the world's major news stories, including conflicts and disasters, in a long photojournalistic career, shooting for leading news publications, such as *Newsweek*. It was, for him, 'a very surreal existence', waking up in the morning and not knowing where he might be that afternoon. 'I saw a tremendous amount of human suffering, of moments where life was much less than what it can be. Paris has offered me an incredible balance.'

If the idea of Paris as the eternal 'lovers' city' sounds a bit clichéd, then Turnley's pictures show that there's a truth in it. He first visited in 1975, and was particularly taken by the history of Paris in relation to photography — it was the home and workplace of many of his heroes, such as Henri Cartier-Bresson, Robert Doisneau, André Kertész, Édouard Boubat and Willy Ronis — and he determined to return. He moved there in 1978 and has stayed ever since.

As he wrote for the publication of his book, this series is 'a tribute to many of the wonderful moments of romance, beauty, hope, and love that I have witnessed and been inspired by in Paris, my adopted home, over the past 40 years. I believe that photography is ultimately about sharing.' These pictures serve as a counterpoint to Turnley's news work. When shooting the streets and cafés and bars, he states, 'I'm constantly reminded of how beautiful and wonderful and poetic life can be.' For Turnley, his **long-term commitment is not just about documenting a favourite city, but about restoring a balance to photographing the human condition**. While acknowledging that it's far from a perfect city, with many sociological problems, Paris has always offered Turnley a way of restoring hope.

↑

Peter Turnley
Concierge and his wife, Rue de Lappe, 1984

Turnley does not work in a surreptitious fashion. Describing his approach to photographing people, he says, 'I think it's very important that I look them in the eye . . . I think people most often pick up on the energy and intent that one brings to one's work.'

This is another form of access — a technique if you like. 'There's an amazing connection that can take place just through eye contact. There have been times in my life when I've been photographing someone I've never met before, I've never seen before, and in a period of between a very quiet thirty seconds to five minutes there's literally an amazing exchange of love in the interaction between two sets of eyes.'

Join the cause

In the words of photographer Stuart Freedman (see Home Territory, page 40), who has won awards from the human rights charity Amnesty International, **'If you're going to go to the other side of the world — or across the road — and stick your camera in someone's misery, you'd better have a good reason to do it.'** One of the most compelling reasons is to raise publicity in the hope of raising contributions for a cause.

David duChemin has specialized as a humanitarian photographer for several years. In 2009, duChemin was introduced by a friend to The BOMA Project. A US non-profit and Kenyan NGO, it was started by former refugee worker and safari guide Kathleen Colson to give women in the arid lands of northern Kenya the means to lift themselves out of poverty. DuChemin was hired to do a series of portraits and editorial images for their website and annual general report. He says:

'This kind of work is one hundred percent relationship, slowing down, nurturing trust, listening well, and connecting. As an outsider, the best way that I've found to do that is to serve alongside people that are already doing that and to lean on the trust they've taken so long to build.' – *David duChemin*

DuChemin freely admits that he couldn't have made the body of work he did here without a man named Kura who speaks eight languages and is committed to the cause. As such, he is deeply trusted. This is another good example of the value of finding a bridger (see The Bridger, page 72).

'Specifically, when I find a scene I want to photograph, I leave my gear in the truck and Kura introduces me . . . We shake hands and through Kura I ask how he is, how his flocks or herds are, and how his family is. I ask about the rains. And then I ask if I can photograph what he's doing, which is gentler than asking to photograph the man himself. Kura takes over and gives details about why we're doing this, asks the man just to pretend we aren't there, and only then do I get my cameras and we do that dance with light and moments . . . '
– *David duChemin*

↑

David duChemin
˙ Joel Leshargole watering camels in Northern Kenya. Ngurunit,
Kenya, 2015

DuChemin made the image above in Ngurunit for the NGO The Boma Project. He recalls, 'I used a wide-angle lens, a low point of view, a sense of timing and some luck, but that's not ultimately what makes photographs like this: they happen by repeated exposure to places and people, and the kind of trust and connection with people that can't happen quickly or alone.' He is keen to stress:

'That connection and trust leads to better stories, and more collaborative opportunities, and it's those that create the context for making the strongest photographs.' – *David duChemin*

NGOs and the people who work for them tend to have greater levels of trust with the communities they serve as they are dedicated to the same cause.

Inspiration is for amateurs

One of the most unhelpful ideas when it comes to making art of any kind, including photography, is of that of the muse. It sounds good — romantic even — to have a personalized spirit who appears when you're in need of inspiration, and it may be the case, but the problem with this kind of high-philosophy thinking is that it's also a really good excuse for not doing any work. Garry Winogrand, the prolific American street photographer and teacher, put it bluntly, 'You learn from work.'

Nothing magical about that, is there? Winogrand wasn't the first to debunk this hypothetical approach to creativity. Picasso wrote, 'Inspiration exists, but it has to find you working.'

What this means for photography is that **in the process of taking pictures, we develop ideas, such as interesting ways to compose a shot**. We have one advantage over every other creative activity — the camera. You pick it up, look through the viewfinder and you're already on your way. It doesn't work like that with a pen (or keyboard!), and I can say that as a writer as well as a photographer. The camera will take a fully formed picture just by pressing the shutter.

Most of us have days when we don't feel 'inspired'. Nevertheless, professionals and others who are really motivated don't have the luxury of waiting for a better day. There's a schedule, even if it's only a commitment we made to ourselves. Above is a picture taken in Brussels on a day when I just didn't really want to go out to shoot. Late in the afternoon, never a bad time to shoot in a city, I used an old 500mm mirror lens that I'd been experimenting with, knowing that it would encourage me to look for things in that unusual way that long focal lengths do. Sitting in an open-air café in the Place Sainte-Catherine, I watched

↑

Garry Winogrand
Los Angeles, 1964

←

Michael Freeman
Place Sainte Catherine, Brussels, Belgium 2016

people and began to see possibilities, such as this very expressive gentleman. Getting out of a funk can be as simple as that, and this is only one of many times that I mechanically got going, rather than gave up based on the inspiration fallacy.

We can take this no-nonsense advice a step further by being healthily suspicious about the word 'art' itself. By no means am I singling out artist-photographers, but if you start to feel overly precious about the purpose and value of your photographs, that can be another obstacle to accessing your subject. It may be overkill to drag in yet another quote, but Nike's slogan **'Just Do It'** also applies here!

Swim with the fish

There are times when you can achieve a kind of invisibility (see Be Invisible, page 46) by joining the very people that you want to photograph. **Becoming a part of your subject can give you extraordinarily candid access**, not just so that you're able to shoot at will from as close up as you'd like, but also so that you're able to take the time to catch a particularly perfect moment.

Jennifer Barnaby is Canadian but for much of the year she lives in Monaco, the second smallest country in the world. In theory, it should take an hour to walk from one end to the other but, but Monaco is a popular tourist destination, especially in the summer when the weather is superb and people visit from all over the world. In August, she says, the visitors outnumber the locals ten to one.

'The crowds drove me crazy until one day I had an epiphany: I started to look and act just like the tourists. I carried a camera around my neck. I stopped to photograph things and people just as they did. I stood around a lot and stared at things. Gradually it dawned on me that I had more in common with the tourists than I did with my neighbours. I had two thoughts: merging into the crowd could be an intriguing way to photograph and it was happening right outside my front door so it could become a long-term project.'
– Jennifer Barnaby

The approach paid off. The picture opposite was taken in the hugely popular Casino Square, where the crowd is crammed into a semi-circular sidewalk about a metre deep facing the Casino. 'I have to be in the right frame of mind to take it on but when I do, I love to wade into the fray and wait for something interesting to unfold. Because the sidewalk is so narrow, I'm usually taking photos at really close range — a foot or two away from people. I enjoy this. I'm at my stealthy best. I'm one of them.' The two women are taking a selfie, though you can't see the camera phone in shot. 'I liked the glint on one woman's sunglasses and the way they looked so happy and glamorous and ostentatious. For me it's a portrait that personifies Casino Square.'

↑
Jennifer Barnaby
Monaco, 2019

↑

Jennifer Barnaby
Monaco, 2018

The more inconspicuous you can make yourself, the more you can get away with. Barnaby says:

'I use a small mirrorless camera so I look harmless and discreet. As a woman, I think I have many advantages as a street photographer. I can easily meld into a crowd or stand in one place for as long as I want to take photos and no one seems to care. I'm also a believer in the "I was here first" philosophy, whereby if you happen to drift in front of my lens you may have your photo taken.' – *Jennifer Barnaby*

It also helps having a small territory, and one you're very familiar with, so that you know where you're most likely to get a good shot, as was the case for the photograph opposite.

'One of my favourite, year-round places to photograph is the panoramic lookout over Monaco. It's a small space dotted with benches, old-time telescope viewers, statues, bronze cannons and a few pyramid-shaped piles of cannonballs. When I arrived at the lookout, I saw the girl leaning on the cannonballs. I liked her position and the expression on her face. She looked lost in thought, which is something I often seek in street subjects . . . I took a shot, stood still and waited to see if something else would happen. Seconds later a woman carrying a purse entered the scene and walked towards the lookout. I took another shot. A pigeon flew into the scene. I took another shot. When a pigeon landed in front of the girl, her trance broke and she looked up at me. I took one last shot and then I moved on. It was over in seconds.

'I love this photo . . . Everything came together. It was as if I were witnessing someone else's dream or that I arrived at the cinema in the middle of a film and nothing makes sense.' – *Jennifer Barnaby*

Embed

This became a popular term during the Afghanistan and Iraq wars in the early 2000s, where the military solution to dealing as positively as possible with the nuisance of combat photographers was to draw them in and 'embed' them within a unit, rather than having them wandering around on their own. Although this means the photographer has less control, it does lead to some remarkably good photography, such as the late Tim Hetherington's book *Infidel* and film *Restrepo*.

In a less dramatic way, embedding yourself within a community you want to photograph means settling in, building trust, and eventually becoming a sort of honorary member of the group. It takes time, inevitably, but it really does pay off in terms of access to ordinary life — you end up getting natural behaviour, actions, expressions, without having to be surreptitious.

Tight-knit communities have furnished some of photography's best picture essays, from George Rodger's *Nuba* to W. Eugene Smith's *Spanish Village* and William Albert Allard's *Amish Folk* (see Straight Talk, page 52). The more isolated a community is from mainstream society, the more fascinating we find them, and for the photographer lucky enough to have unfettered access, they can be an original coup. I said lucky, but it's not the kind of luck that most people might think of — the good fortune to come across an isolated community. It's the luck

↑

Michael Freeman
Akha girls collecting water,
Chiang Rai Province, Thailand, 1980

↑

Michael Freeman
Akha funeral, Chiang Rai Province, Thailand, 1981

of being able to spend the time and have the resources to embed yourself so thoroughly that you become a part of their flow of life.

This is what field anthropologists do, and while you might not be writing a dissertation on the people you are with, you're ultimately creating valuable documentation — the photographs will stand forever as a visual record accessible to everyone. Understanding the dynamics of a culture and what makes it distinctive is at the heart of anthropology, and the role of a field anthropologist is to experience being within an independent culture while also looking at it objectively. You need to combine both familiarity and distance. Taking sides and entering disputes is absolutely the worst practice.

My first direct experience of this type of work was a three-month assignment for Time-Life Books on an ethnic minority in the highlands

of the Thai-Burmese border: the Akha, a hill-dwelling community scattered over the last outliers of the Himalayas that stretch, finger-like, into northern Myanmar, Southern Yunnan, Laos and northern Thailand. Of the several hill-dwelling peoples in the area, the Akha are the most conservative, which was a factor in Time-Life's choosing them as them as a subject, as their dress at the time remained traditional.

This was before mass tourism, and the biggest challenge was gaining trust and acceptance. As with most mountain-dwelling peoples, their relationship with the lowlanders was not particularly good — they were marginalized and looked down upon. Time-Life contracted anthropologists who already had access and we eventually corralled them into making introductions and getting us embedded in one village.

Aside from the logistics, I learned a valuable lesson from my experience among the Akha: part of the process of becoming embedded requires not taking photographs. One thing that few photographers think about is what you look like when you use a camera. It hides your face, and not in a nice way. It's a plain truth that if you want to build trust among a group of people, you have to look them in the eye — a lot — and engage with them like a normal person.

When you shoot, you're no longer just another person, so to get to the point where your subjects don't mind this, they have to know you and accept you. I didn't use the camera for the first two weeks. After that, I could do whatever I liked, and people would make suggestions and take me along to anything that they thought might be remotely interesting for me. Ultimately, many in the village came to see the book and my photography as their project also.

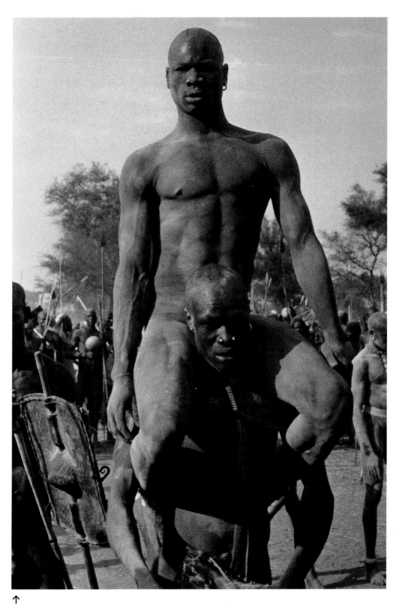

↑

George Rodger
Sudan, Kordofan, The Nubas, 1949

Extra sensory

I hesitate to bring up the overused word 'zen', but one of the things that happens when you really immerse yourself in a shoot (and probably many other activities too) is that you find yourself on a slightly different plane. A plane where you're more aware of what's going on and are somehow more connected. There's an element of mystery as to what's really going on here, what many people casually call 'magic', but there are enough photographers who attest to their experience of it to be able take it seriously. Matt Stuart, featured earlier (see Boots on the Ground, page 14), says, 'You can lose yourself when you're doing it and almost forget that you're there. You're like a floating pair of eyeballs, and I really do find it meditative.'

Heightened awareness is the reward of such total concentration. Stuart sees three 'levels of engagement'.

'The first level is the negative one when you're going out on patrol to make sure nothing is happening and you're not missing anything, which works well in a military analogy but of course isn't much use when you're a photographer. Level two is when you're engaged and you find some things are good, but you stop for a coffee and maybe a sandwich and look at your phone, so you're not fully engaged. Maybe you come back with a few bits and bobs, but that's all. The third level is when you're completely immersed.' – *Matt Stuart*

When you reach the third level, you are able to sense the slightest change in the rhythm of life and subject matter around you, and you're completely aware. Everything's heightened, from your sense of smell to your sense of hearing, as well as visually. As Stuart puts it, 'You're almost thinking the same as the people you're photographing.' Having such acute sensory awareness enables you to anticipate what's about to happen. For the image opposite, Stuart explains how this came into play:

'This was outside the National Gallery, and what had happened before was that there was a guy . . . who was sort of dancing by himself, very badly, to some music in his earphones. And there were some school

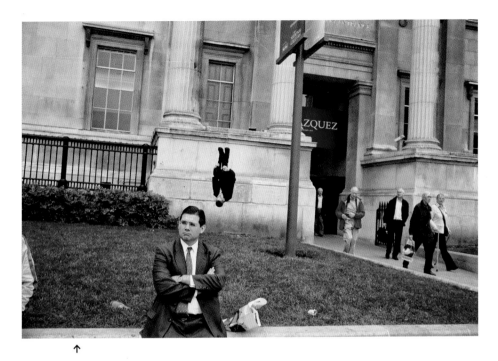

↑

Matt Stuart
Trafalgar Square, London, 2006

kids who started clapping, but in a way making fun of him. One of them started to body-pop. Then another turned to his friend and said, why don't you do your somersault? The other boy replied, "I'm going to have to practise it first on the grass." So, I'm listening to this conversation, edging a bit closer, and I could tell that something was going to happen. I followed them, and he had one attempt, and I caught him mid-air and upside down. He landed and slipped, so he didn't do it again. I love that no one else in the picture knows what's happening.' – *Matt Stuart*

Only if you mean it

One way of gaining complete access in photography is to go through a process of assimilation with your subject. This may even be involuntary, or at least it may just happen to evolve, as happened to Spanish photographer Xavier Comas. Based in Bangkok, he decided out of curiosity to take a trip to the South of the country in 2009 when political unrest was spilling over into violence. He recalls:

'I was intrigued by the fact that in Thailand, so popular among tourists, here was this place that no one seemed to want to know about. The Thais didn't seem to want to even hear about it. It was dark, dangerous, off the regular map.' – *Xavier Comas*

The first thing he did when he arrived in the southern city of Yala was to buy a bicycle to be able to move around slowly and at everyone else's pace. From here he moved to Narathiwat, the least developed town and province, with more of a feeling of the old Muslim south. 'I was looking for adventure, and after reading a little about it, and the usual travel advisories, I didn't want to read any more. I wanted to go without preconceptions. I don't like to plan too much, nor to feel fully focused on the photography, because I think that way you can lose the thread.'

Little realizing that this would become a four-year story that would absorb a part of his life, Comas began simply cycling around and exploring. As a rare Westerner in a conflict zone, he was highly visible, but at the same time was doing nothing unusual or eye-catching. This vulnerability served as a kind of protection, because he soon became familiar to the locals. As he passed by a tea shop, a couple of men beckoned him to join them, he stopped. **'It is impossible to find the extraordinary without opening ordinary doors,'** he says. Over tea, they chatted, and at one point one of the two friends suggested that he take Comas to see the House of the Raja — or Ruma Rajo in Malay — a dilapidated wooden palace that he thought might interest the photographer.

This was how Comas's long project began. Dark and decrepit, though previously grand, the old palace had a strange atmosphere. The family

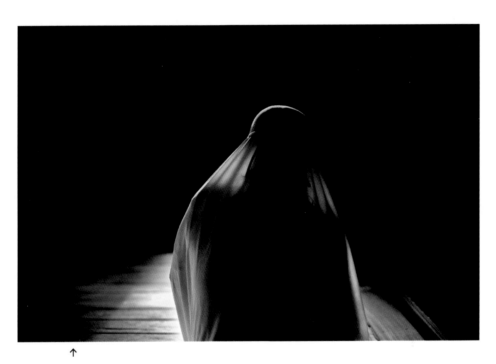

↑

Xavier Comas
From the series *House of the Raja*, 2014

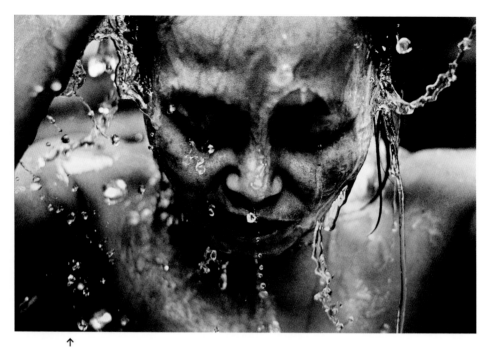

↑

Xavier Comas
From the series *House of the Raja*, 2014

who lived there, but did not own it, accepted his presence after an initial introduction.

'Driven by an innocent curiosity, the children dogged my steps as I made my way around . . . I paid regular visits to the house, often stopping by the small shop across from the nearby mosque to buy local sweets for the children and some food and some drinks for their mothers. I felt that Fatimah and Faridah [the two women living there] truly appreciated my company and my concern.

'I would never have imagined that after crossing its entrance, and as the outside world closed behind me, it would draw me into the depths of my consciousness.' – *Xavier Comas*

This was only the first trip of three, and for Comas the visits represented three stages in how that relationship grew.

'The first was discovery, but it wasn't until the second trip that I started to really photograph, and moved in to live there. Emotionally, though, I became conflicted, between wanting to stay and wanting to leave, and it wasn't until the third trip that I finally became assimilated. This third trip was during the rainy season, which is quite tough in that part of the world, with the monsoons, the damp, the mosquitoes, but it was then that I felt at peace.' – *Xavier Comas*

The house had a history, and indeed had been the residence of the Raja of Legeh. In its day it was the centre of a large compound with buildings for relatives, guests and a private army. The Raja died before the Japanese occupation in the Second World War, and with complicated changes of fortunes, became virtually abandoned. Comas found himself drawn in and gradually built up a remarkable body of work. The entire book, of which the two pictures give just a hint, evokes the sensation of a place out of time, with an intensity that could only have come from living in and with the subject.

The takeaway

Let a project drive your shooting:
Set a long-term project that requires shooting 365 days of the year to help you stay motivated.

Don't always raise the camera:
When the camera's in front of your face, it can be a barrier to communication with the people you're photographing.

Slow down:
Seek quality over quantity. Compose carefully, time your shots and focus on a few good opportunities rather than many average ones.

Deep Learning

4 ←

The more you know, the better you'll be. That doesn't sound quite as appealing as being able to chalk up your best work to a stroke of genius, a moment of effortless brilliance in a rapidly caught picture. Most photography, even most good photography, is created at around 1/125th of a second, even faster with a phone camera. That's just the nature of how cameras work, and it has given rise to the notion that there's less work to do than in, say, painting or writing or video. For more casual kinds of shooting, this may be true — if you have a good eye and are in the right place at the right time, as we saw in the first chapter, you're likely to get some good shots. Some areas of photography, however, are more demanding, and take time and effort to master.

The good news is that if you're OK with spending the time to really get to know these more challenging fields, you will have guaranteed access into them. This isn't going to be for everyone. With studio work, especially still lifes, and with subject-specific photography, such as wildlife and sports, you need not just niche knowledge but a willingness to invent your own way of working, your own techniques and even your own equipment. Ultimately, access to these kinds of subjects means getting to know exactly what makes them tick.

The basic benefit of deep learning is that almost every kind of shooting improves when you dig down inside the special quirks and needs of whatever you're photographing. And every subject can be special if you choose it to be.

That's also when it becomes intense, and committing to this deep dive is what separates the top imagery in the field from the average. It means learning two subjects exhaustively: not just the techniques of shooting, but the subject itself, which may be completely new to you.

Esoteric knowledge

One of the most specialized areas of photography is studio work, and nestled within that discipline are even more arcane specializations such as automobile photography (how do you get a smooth perfect light reflecting in the bodywork of a Mercedes Maybach?), and food and beverage photography, known in the business as F&B. Too specialized, perhaps? Wait. Just think of this as a method. It doesn't matter right now if you're supremely uninterested in food (which would put you in the minority), because **you can take this really obsessive approach to just about anything you like**.

The sole objective of F&B photography is to show a dish or drink at its absolute best. To be mouthwateringly desirable. Nothing else. Not such a radical aim, and much less complicated than reportage photography. Even 'innocent', in fact, in the words of former Detroit photojournalist-turned top European food photographer Bob Golden. **The challenge here isn't ethical or philosophical. It's purely executional**.

↑

Photographing food, Shanghai, China, 2018

That's where it becomes intense, however, and *commitment* is what separates the top imagery in the field from the average, because this kind of specialization demands that you learn two subjects completely: not only lighting and photography techniques, but also, in this case, the culinary knowledge. You have to know almost as much about how items of food are prepared as a chef does, including the finer points of what can go wrong and what needs to be right. Average doesn't cut it in the studio.

↑

Michael Freeman
Smoked cocktail, London, 2019

Short of apprenticing with a top F&B photographer for a couple of years, if you want to make it in this field, you will need to do some really detailed research. First, you need to find the most highly regarded imagery used by the top clients. That means looking at the websites of Michelin-starred restaurants around the world, as well as those rated highly in other surveys. Next, find out who the photographers were, which takes a bit more work. After that, study the top images and try in your mind to reverse-engineer them in order to understand how they were made.

There's an entire book to be written on this topic, but the fundamentals are as follows. Learn all there is to know about the dish you will be shooting from the chef — especially find out what can go wrong and what demonstrates that it's perfect. Know what kind of light you need and where it should be positioned to make the important bits look fantastic. If you want food to look and feel delicious, never light from the front. Unless you want to be arty (which is OK at times), bathe it in soft light rather than stab it with a harsh spotlight. If you want it to look like most other food shots, place the dish on a rustic table next to a north-facing window and stand on a chair aiming down. Otherwise, create your own light. As you see, it's almost all about light.

Incidentally, fakery is NOT a stock in trade of high-level F&B shooting, contrary to popular imagination. Mashed potatoes to simulate ice cream, acrylic ice cubes (both solutions to on-set meltdown), mixing a pizza cheese topping with glue to make it gooey are just cheap, semi-clever tricks to make up for badly prepared food and poor technique.

So, for instance, if you want ice cubes and spheres to look wonderful, you need to order professionally clarified ice, and lots of it, from a specialist supplier, and then carve it into shape. The result of using a special and slow-freezing process, clarified ice has none of the micro-bubbles that give the ice in your home freezer its cloudy look.

You can take this meticulous approach into any field. Portraits? Start with the top platforms that show portraits of famous people. *Vanity Fair* for example. What photographers do they use? What are the styles?

↑

Michael Freeman
Dim Sum, London, 2019

And so on. Gathering this kind of esoteric knowledge makes a real difference. If you have skill and dedication, and are happy with shoots that demand planning and control rather than the ablity to wing it, you will succeed. **You just need to be able to identify the best work that has ever been done in whichever field you've chosen, work out the techniques that have been used through observation and experimentation, apply them yourself, and you're there.**

Invent your own

As a field of creative work, photography is ripe for creating specialties.

They may be special ways of composing, of lighting, of dealing with people and other subjects, and they may also be specialities created by inventing entirely new ways of shooting, starting with the technical and going on from there. The image opposite is a fantastic example of the latter. The concept is a straightforward combination of two things — except that no one had thought of it before Howard Schatz, a highly successful American studio photographer who works in both editorial and advertising. He put underwater and fashion together. Actually, more than fashion: insert ballet, portraiture, even a kind of graphic novel too. Essentially, he harnessed the special physical qualities of the underwater realm to photograph people as if they were ethereal, floating, otherworldly.

There is an exhausting number of technical issues to master before even beginning to explore the creative opportunities of such combinations, but Schatz did just that – refining his underwater studio photography over years to become the unchallenged expert in the field. This expertise began prosaically:

'In 1990 my wife and I bought a piece of land in Marin County, California, just north of San Francisco, and we designed a house together. I love sports and I wanted an indoor swimming pool that had a basketball hoop over the deep end of the pool at just the right height for me to shoot baskets from the water. One day I got splashed in the eyes by the ball landing right in front of me, so I put on a pair of goggles. It was at that moment that I realized how interesting the world under the water looked. I began to think about making photographs underwater.'
– *Howard Schatz*

He bought an underwater housing for his camera and began to experiment and learning about the 'otherworldly underwater realm'.

↑

Howard Schatz
Underwater Study #980, 1998

↑

Behind the scenes, Howard Schatz underwater shoot,
by Tom Sperduto, 2015

'I soon realized that the underwater world as a beautifully weightless slow-motion environment was magical. For the next six months, I began to explore ways of making images underwater. Nobody could help me with technique and all the other difficulties and roadblocks either, because the other underwater photographers I knew went deep underwater with scuba gear and lights to study fish and fauna; I wanted to photograph human beings.' – *Howard Schatz*

It took six months of work on composition, exposure, resolution, colour correction, lighting, water chemistry, water temperature, clarity and a host of other challenges, before Schatz felt he could make great images that he had complete control over. When he did, he called his friend, Katita Waldo, at the time a prima ballerina from the San Francisco Ballet, 'and set to work to make images that surprised and delighted' him.

The next step was to construct a state-of-the-art, custom-built pool fitted with ports for studio strobes and covered with a clear plastic giant dome in the winter. The strobe lights that are in place under the pool's deck are set off by radio transmission. However daunting though all this technical mastery may seem, the real next-step challenges were the creative ones, many unexpected. For instance, extensive casting, always a unique test for models and dancers, is needed to find models who are not only beautiful but are, as Schatz puts it, 'at one' with the water, and can perform submerged with precise direction. In addition, he says, 'when water meets air a reflection occurs. When I'm under the surface, I can use the mirror-like quality of the air/water interface to make fascinating, unique and dramatic images.'

Like in many highly specialized cases, this may seem at first like an extreme example. **The point is, however, that through determination and imagination, Schatz has made the photography of humans underwater his own specialty.** It's by no means his only style of photography, but in this field he has no rivals.

Genre skills

Some kinds of photography are very much subject-focused, and they usually require a strong understanding of the quirks and behaviour of that subject. Few more so than wildlife, where, of course, access is key. There are two stages of gaining access: first, finding the animals, then getting close to them. Having experience helps massively, but when you first start out, how do you confidently make those first steps? Let's jump straight to the top of the list of desirable wildlife to photograph — large predatory animals. This might seem, as Jon McCormack elegantly puts it, 'an exercise in pure terror', but if you prepare for it, learn, and draw on the experience of others, it's both possible and safe.

McCormack says that this potentially high-risk genre of photography is all about understanding, analysing, minimizing, and accepting those risks: 'After all, bears, sea lions, lions and sharks all survive by eating lesser animals — why shouldn't I be on their menu?' So much of nature photography is actually spent doing research. For example, knowing when animals will be in a habitat, or knowing whether they will be approachable. For McCormack, 'This is the real work. Taking a photo is only half of the story. Coming back alive to publish is what really counts.'

'Take bears for example. In general we think of them as dangerous. Sometimes they are. Mostly they just want to know you aren't going to bother them. In early spring, coastal brown bears are starving after a full winter of hibernation. Pair this hunger with a mother caring for a cub and you have one of the meanest, most aggressive beasts in nature. It would be close to a death wish to be on land with a pair like this.' – *Jon McCormack*

Sensibly, McCormack shot the photograph opposite from the safety of a boat. However, move the clock forward six months and bears have full stomachs from a summer of gorging on calorie-rich salmon and they are thinking only about easy food sources.

McCormack continues: 'I spent 20 minutes squatting on the ground in front of this giant fat female and she didn't have a care in the world. There were millions of calories of tasty mussels between her and me.

↑

Jon McCormack
Grizzly Bears, Khutzeymateen, 2013

↑

Jon McCormack
Sea Lion Bite, 2015

As long as I didn't bother her, she wasn't gong to bother me. Even with these ideal conditions, however, fear does creep in. Eventually this bear needed to get up and move to find a fresh place to dig. As she stood up on all four legs (not close to her full height) she towered above me. To this day I think the smell of fear is bear breath.'

The remarkable shot of a sea lion shown opposite, which looks like it could be the photographer's last, is in fact *within* the zone of acceptable risk, surprisingly. Well, not completely risk-free, but not in the same league as shooting the grizzly bears. McCormack says, 'Sometimes fear is just primal. No amount of logic and research matters. Steller sea lions can be huge. Hundreds of pounds and ridiculously fast and agile under water. One of the primary ways they interact with their environment is by biting things. This method of exploration creates some of the scarier moments in natural history photography.'

'On my first dive with Stellers I jumped into the cold winter waters of British Columbia and started to kick slowly towards the colony. One of the more curious sea lions broke off and started to swim towards me — gaining speed with every stroke of its flippers. As it closed on me, these giant jaws opened. My only thought was, "Oh . . . so this is how my life ends . . . a giant set of jaws and a muffled scream." Remember, the sea lion is in its natural habitat, but I'm a land mammal in a bunch of clumsy gear who can't outswim anything. When the bite came it was strangely gentle. More of a handshake mixed with a "what exactly are you?" squeeze. I'm enthralled by these gentle giants . . . The more you play, the more excited they get. Oddly, this is where things *can* get risky.

'So why take these risks? . . . I believe that the more we understand animals, the more we will make decisions to protect them and the places in which they live. My hope as a photographer is to present them as they really are — equal co-inhabitants of this fragile planet we all call home.' – *Jon McCormack*

Adapt technology

Drone photography, so enthralling when it first became possible, has already become familiar, and the ability to shoot low-level aerials with precision is no longer striking just on its own. Perhaps if I'd been writing this book several years ago, drones would have made an entry as a different way of accessing landscape, but not now. **New technology, however, has a habit of rewarding people with imagination.** Chicago-based Reuben Wu does fine-art landscape photography, which is a heavily subscribed area. 'We're overwhelmed every day by images of our planet, and they're very beautiful,' he says, 'but what I wanted to do was to go beyond that, and show almost an abstraction of the landscape.'

When looking for a radically different way of treating landscapes, without relying on artificial effects, he came across a new development in drone technology — aerial lighting. The unit he acquired was a compact LED light designed to be carried underneath the drone, the equivalent of a 200-watt tungsten lamp, fitted with a Fresnel lens that doubles the lux in the centre of the beam. Shooting in the American West, he scouts out some of the most barren landscapes during the day, then sets up and waits until night. 'My gear setup is pretty minimal. A lot of it comes down to how much I can carry. Many of my locations are pretty remote and I have to be able to hike to these places.' He launches the light-carrying drone and positions it over the landscape, directing the light beam and making five-second exposures, effectively painting with light and then combining the exposures in post-production.

'I was looking how to illuminate obscure landscapes,' Wu says, and he managed to do so in a way that makes the Earth look like an alien planet. Wu titled his project *Lux Noctis*, and describes it as 'a series of photographs that show landscapes in the framework of traditional landscape photography and 19th-century romantic painting, but also influenced by science fiction and geological time.' He adds, 'And also the fantastical notion of planetary exploration.'

↑

Reuben Wu
Lux Noctis LN0309 (Arizona, 2018)

Source material

Before he made *Barry Lyndon* in 1975, Stanley Kubrick believed that there had never been a convincing historical movie. He himself had been trying to make one since the late 1960s, when work began on a film about Napoleon, though nothing came of that project. He said, 'It is difficult to make a film about a historical figure that presents the necessary historical information and at the same time conveys a sense of the day-to-day reality of the characters' lives.' Determined to be the first to succeed in doing so — and in my opinion he was — Kubrick and his production designer Ken Adam set about creating a fundamentally authentic 18th-century experience. **The photography was key to this, and Kubrick, who worked in his early years as a photographer for *Look* magazine and was always a photographer at heart, created the period visually in a way that was completely believable.**

There were two keys to this. The first was to shoot in the style of the 18th century, and the second was to film in the light of that period. No one had ever tried either before. 'I suppose you could say it is a bit like being a detective. On *Barry Lyndon*, I accumulated a very large picture file of drawings and paintings taken from art books. These pictures served as the reference for everything we needed to make — clothes, furniture, hand props, architecture, vehicles, etc. . . . **Good research is an absolute necessity and I enjoyed doing it . . . you have the satisfaction of putting the knowledge to immediate good use.'** In fact, almost every scene is an evocation of a well-known work of art from the period, such as William Hogarth's *Marriage A-la-Mode*, and *Penelope Unravelling Her Web* by Joseph Wright of Derby. This gives the audience a special access to an 18th-century way of seeing.

Adam and his team did the donkey work. Adam said, 'We studied every painter of the period, photographed every detail we could think of; bought real clothes of the period which, incidentally, were almost invariably too small . . . There were enormous challenges too, such as the house of Lady Lyndon. That was like a jigsaw puzzle, a combination of about ten or eleven stately homes in England.'

↑

Joseph Wright of Derby
Penelope Unravelling Her Web, 1783–1784

↑

Marisa Berenson as Lady Lyndon in *Barry Lyndon*, 1975

Kubrick hated shooting on location, and always wanted to build sets at Pinewood or Elstree whenever possible, but he had little choice for *Barry Lyndon* because of his obsession with historical authenticity (see also Obsession, page 78). This naturally included authentic period lighting, and while there were a few scenes in which lights were used, the majority featured only natural or ambient light. Kubrick had a particular desire to show what interiors must have felt like in the evening in the days before electricity and went to enormous lengths to acquire what are still the fastest camera lenses in existence — those made by Zeiss for NASA at undisclosed cost and with the insane maximum aperture of ƒ/0.7. Ed Di Giulio was given the job of converting this lens to fit on a 35mm Mitchell camera, and questioned the value of going to all this trouble. Kubrick explained that it wasn't a gimmick, he wanted to preserve the 'feeling of these old castles at night as they actually were'. The addition of any fill light would have added an artificiality to the scene that he did not want. As well as the special camera and lens, Kubrick had three-wick candles that burned much brighter than regular candles custom made. All of this to be authentic.

As Kubrick said, 'I spent a year preparing *Barry Lyndon* before shooting began and think this time was very well spent. The starting point and *sine qua non* of any historical or futuristic story is to make you believe what you see.'

We can all do picture research for any project requiring a certain look and feel. Your source material doesn't have to come from a movie or a coffee-table book, either. **There are so many sources online to choose from, from Pinterest to sites dedicated to esoteric themes. Get obsessed with the details and apply what you learn to your shots.**

Factory visits

Studio still life photography was at the height of its popularity in the 1970s and 1980s, when it was the default for advertising campaigns. It was cutting-edge, well paid, and the top practitioners were stars of the advertising world. Things have changed drastically since then, in part because of shifting fashions in style and content. But in that heyday a huge amount of effort went into researching and perfecting the imagery of otherwise quite humble products. Think about it. If a single object on a table in a studio has to carry the full weight of an important ad campaign, it's going to come under the most intense scrutiny imaginable, from art directors and clients to the person at the sharp end — the photographer.

In London, the most famous and admired still life photographer was an American, Lester Bookbinder, with a reputation for perfection and inten-

sity that often intimidated the people who worked with him and for him. Set art director Martin Hill wrote, 'One of his tricks was to direct a carbon arc light across the set to highlight any imperfection . . . To have him walk on set on the morning of the shoot and just nod his head in approval was one of the art director's highlights.'

In 1968, Bookbinder was hired by the equally demanding and difficult art director Roland Schenk to take the cover photographs for *Management Today.* Fortunately, he and Bookbinder saw eye to eye, and the series received accolades for its coolly precise creativity. Their first cover together (shown

↑

Lester Bookbinder
Management Today, February 1968

opposite), illustrating an article on the Ford management method, set the pattern. Subjects such as management and banking are notoriously difficult to illustrate in an interesting way, which is where imaginative still life photography comes in. The first thing Bookbinder did was visit the Ford factory for inspiration and there he found a casting block, the mould where hot metal is poured for different parts. Bookbinder's style was determinedly abstract wherever possible. This was his also one of his preferred lighting styles: very clean yet surprising, combining a backlit silhouette with a spotlight. The result is an attractive but intriguing image, just enough art so that people would be happy to have the magazine lying around on a desk or table.

One of the first things everyone did in advertising when pitching for a new account was to visit the client's factory. The theory was that you could always find something that under the client's nose that your brilliant creative team could make use of. **In terms of access, think of the 'factory visit' as an allegory for getting to know how your subject works. If you want to understand something so that you can photograph it better, go and see how it's made.**

The takeaway

Know your subject:
A photograph can simply act as record, but learning about your subject will always lend more depth and resonance to your pictures.

Make the most of technology:
Just as there are new apps to help you be in the right place at the right time, equipment that can help you get closer to and more involved with your subject is developing constantly. Keep abreast of invention, whether it is mainstream or crowd-funded.

Research opens doors:
Preparation is key, and smart online research will give you insights that may surprise you and help you get closer to your subject.

Left Field

I was tempted to name this last chapter 'when all else fails', but that would do a disservice to the inventive and imaginative solutions of the photographers featured here. **Creativity is the theme here, and I'm calling this chapter Left Field because the solutions and ideas are unusual and unexpected.**

This chapter probably has the most diverse range of photographers and access solutions than any other in this book. Street photographer Stuart Paton challenges the idea that photography requires precision, and a 'decisive moment', by embracing life's imperfections, preferring images that are 'slightly dirty behind the ears'. Joel Meyerowitz argues the case for leaving some things unexplained, so that the viewer can participate and wonder what was going on. Thomas Joshua Cooper sets very strict limits for himself, including allowing himself just one attempt, one single shot. The unique French fashion and editorial photographer Guy Bourdin made creative history with his campaigns for a high-fashion shoe brand, in which he had the shoes walking off by themselves on disembodied mannequin legs.

In Cristina de Middel's case she wanted to photograph a story that had finished fifty years earlier, that of the 1960s Zambian Space Program, so she made a fictionalized version of it. This wouldn't be strange in the world of creative writing, but in photography there's an idea that what is in front of the camera should in some way be 'real', whatever that means. Instead, de Middel made her own definition of documentary photography: 'Documentary should be more about presenting questions and opening debates than stating the specifics of a situation.' Cindy Sherman has for years followed the fictional route, in a highly personal way, exploring identity and cultural themes by using herself as the model and star of her own productions. Karen Knorr, whom we already saw making the most of her family moving to an exclusive part of London, used digital technology to combine two separate shoots in India in order to bring alive the magical mythology of Hindu gods, avatars and princes. Finally, my old friend Romano Cagnoni sought a unique access to one of the world's toughest war zones by making a studio on the frontline. Their approaches are all so varied, but they are united by the intensity of their imaginations.

Forget perfect

The urge for perfection stems from two ideas. One was crystallized so well by Henri Cartier-Bresson in his 'decisive moment' that it has become a kind of touchstone for reportage and street photographers. The other comes from advertising where everyone involved goes to almost any length to present what they're selling in its most exquisite, ideal form (see Factory Visits, page 130). Both are, in their own way, methods of accessing the subject at its best, but both are controversial. The counterargument is that **it's life's imperfections that are interesting, and this principle can also apply when taking photographs.**

Stuart Paton is known for a particular style of street photography which eschews perfection in favour of what he calls 'messy complexity'. He says it's a reaction particularly to 'the toe-curling "perfection" of most advertising photography which only targets our alienated selves', and he encourages us to 'embrace the spots and pimples of our own photography'.

'Imperfection is woven into the fabric of life. We're struggling individuals in a bittersweet world, so we warm to the human failings we know only too well, whether through empathy or *schadenfreude*. So, far from being a problem, imperfection is the motor of my photography. The impetus pushing me to express emotions and address society.' – *Stuart Paton*

He makes an analogy with Native American Navajo culture, in which 'rug weavers believe they entwine part of their very being into the cloth. So small imperfections called *ch'ihónít'i* (spirit lines) are intentionally incorporated to allow the trapped element of themselves to escape.'

Paton hunts down moments that don't fit as expected. 'I prefer pictures that are slightly dirty behind the ears. It can really undermine your photography if you go out primed with preconceived templates of what you're pursuing.' **This is not, however, an invitation to sloppiness.** About the stairway silhouette photograph on page 138, Patron says, 'I put in a serious shift, pre-visualized my picture and pinpointed my punctum. I made several attempts with various figures

↑

Stuart Paton
From the series *Black Dog Empire*, 2019

but they were too "clean." Until finally, someone stepped out of character, feigning surprise at being caught in my crosshairs. One gunslinger facing down another.'

The opportunity for Paton in the shot above was for social comment. In general, he says, 'On that social level, I hope to evoke the alienation, social dislocation and loss of personal singularity generated by feral capitalism.' In this particular scene, he saw 'a crushed individual adrift in cracked-mirror poetry. Hence the darkness, the dissonance, the off-kilter composition.' **Instead of the cool 'objectivity' of the classic documentary tradition, Paton hopes to touch on something more visceral.**

→

Stuart Paton
From the series *AKA
Repeat to Fade*, 2015

Welcome ambiguity

Many of the strategies outlined in previous chapters have a kind of central aim of reaching a known position — and I'm using the word 'position' loosely, not just in terms of viewpoint. You kind of know what picture you want; it's the goal and all that's standing in your way is the means to get proper access to it. That's fine and understandable, but there may be a risk of seeking too much clarity.

In photography, the default is to show things clearly. At least, that's what the camera makes possible, so for that very reason, most photographers take advantage of this and aim to be clear in their imagery. **There's a compelling counterargument, however, that real engagement with a scene is enhanced by mystery and uncertainty.**

Joel Meyerowitz is a believer in this, and he says that ambiguity 'is what photography has at its core as its mystery and its gift.' His shot opposite is an example.

'There's a car door, a little girl framed in the window, there's the hand of a man on the edge of the door. That's all there is, but it's filled with a kind of ambiguity. What's going on in this picture? Is this man luring the child into his car, or out of the car where she was? Is he her father? Why is she crying? IS she crying or is it part of a laugh that looks like that?' – *Joel Meyerowitz*

Of course, Meyerowitz isn't going to say, and he isn't even going to say if he knows. Instead, he's at pains to remind all photographers that 'as you see something and you begin to move in, and you're photographing as you're moving, the meaning changes with every step you take. What you leave in or what you cut out is part of the continuation of the world outside the frame.' In this picture, what's important is that 'we don't know, and recognizing that is one of the gifts of photography.'

Ambiguity highlights something important about how you can deal with curiosity. **Photographs thrive on curiosity. It's what makes people interested in them and want to look longer.**

There are many, many scenes that we pass through in real life and don't have a full understanding of. Sometimes we're actively puzzled by them, and it's typically at those moments when our interest is sparked. Meyerowitz is by no means the only top-level photographer who sees engagement with his subject in this way. Leonard Freed said that ambiguity was one of the great strengths of photography; everything else, he insisted, was propaganda.

So, for Meyerowitz and a number of other photographers, it's the rich uncertainty in photographs taken from life that offers deeper access into those worlds.

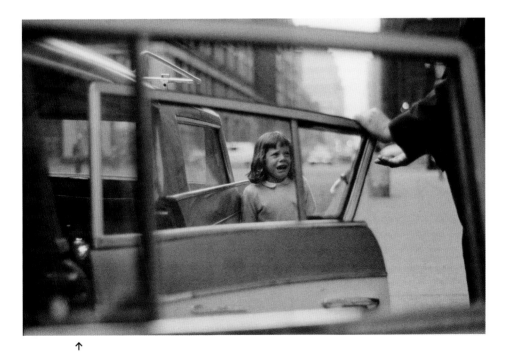

↑
Joel Meyerowitz
New York City, 1963

Going to extremes

Why make things easy? The entire trajectory of modern camera technology and picture sharing (paired beautifully in phone cameras) has been towards ease and speed, and that alone suggests that the reverse direction might be interesting. The American photographer Thomas Joshua Cooper reached that conclusion long ago. First, he photographs in black and white with a 19th-century view camera and plates. Second, he seeks out places that are really difficult to reach. One such example is Prime Head, the furthest extremity of Antarctica, which has had fewer human visitors than the moon. Third, having gone to all that effort, he shoots just one photograph at each location, without the benefit of a screen review to check the shot. Now, if that doesn't focus your attention on the job at hand, what would?

When you go to a great deal of effort to get access to somewhere special, you would always think about safety above all else. I don't mean only your own physical safety, but securing the images safely. Whether on film or a memory card, you'd take precious care of them, and you'd normally take a number of pictures to explore different possibilities. In fact, the more remote, the more exceptional and unrepeatable the occasion and place, the more trouble you might take over this.

Yet here, in the most intense of situations, the photographer is doing the opposite — physically and mentally. He's travelling to the ends of the earth with difficulty, and then intensifying the experience by standing on a personal cliff edge.

The idea of self-imposed austerity seems perverse at first. Why would you do that? What would it feel like to do that? Would you even dare to do that? Many reactions to this project have been in that vein. Writing about the exhibition, the reviewer for the *Financial Times* thought it 'an arbitrary restriction and one that profoundly affects the quality of the whole. Cooper's genius is his own but the result of setting such artificial "rules" is that he jeopardizes his quality control.' A typical comment

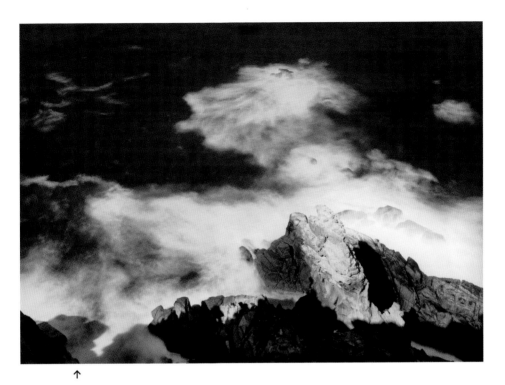

↑

Thomas Joshua Cooper
First Light — The South Indian Ocean, the Cape of Good Hope, #2,
South Africa, the Southwestmost Point of Continental Africa, 2004

on one of the photo forums went, 'Everyone [sic] of us knows that if you have such an encounter ... we stick our finger like glue to the button ... because we have the fear of not taking that perfect picture.'

Of course that fear is understandable. But think about how much fuller and more thrilling the experience of shooting under such conditions would be. You might not want to use this approach every day, but perhaps it's worth trying.

Bring your own

A radically different approach to reportage or documentary photography is to take charge of the scene, or at least insert your own theatricality into it. **Left-field thinking is all about exploring ideas that wouldn't even occur to most other people.**

Guy Bourdin was fashion photography's bad boy of the 1970s, but so innovative that he was the only photographer that *Vogue* gave free rein to at that time in designing layouts. His career spanned longer than that, but it was the decade of the 1970s, in which pop culture was reaching out and lashing out in all directions, that allowed him to blossom. Sexuality and bad taste were Bourdin's key interests, and these in turn came from his time as Man Ray's protégé, when he embraced Surrealism.

Possibly his most fruitful collaboration was a commercial assignment with the French shoe designer Charles Jourdan, for whom he shot a number of imaginative campaigns. The most imaginative of all, however, was pure Surrealism brought up to date. In the summer of 1979, accompanied by his partner, his son and his photo assistant, he loaded up a black Cadillac with several pairs of mannequin legs and shoes and embarked on a month's driving tour of England. The result was a strange and slightly unnerving narrative of disembodied legs parading the high-fashion creations past bus stops, Battersea Power Station, Brighton beachfront, and even, in one of the 22 pictures in the series, tied up on a railway line. *Vogue* Editor Suzy Menkes described them as 'erotic, unnerving images of high-heeled shoes walking, disconnected from the body, along beaches or across industrial wasteland'.

Once an idea as original as this has been done, there's absolutely no point in repeating it, but the principle behind it is ripe for use. It's about theatre, with the photographer acting as set designer, fitting props into an existing scene. 'Fitting' doesn't mean that the props have to blend in at all; as with Bourdin's mannequin legs, the contrast can make the picture come alive. And as we'll see next with Cristina de Middel's work, you can extend this into creating another world (see Invented Worlds, page 144).

↑

Guy Bourdin
Charles Jourdan, Fall 1978

Invented worlds
What happens when you find a subject that would have made a great picture story, but it's over and done with, finished, disappeared? Or maybe it didn't even happen the way it should have, or in the way you would have liked it to? Do you feel a twinge of disappointment, walk away and go on looking for something else?

You don't if you're Cristina de Middel, a successful Spanish-Belgian photojournalist, who gave up that career to explore alternative ways of shooting. 'I didn't find it a good platform for the way I thought,' she says, 'so to amuse myself I began exploring a way of telling stories in which I deliberately played with fiction.' Her attention was piqued by what sounded like a fantastical project from the 1960s — the Zambian Space Mission Program, first to the Moon, then to Mars.

I remember reading about it, because it was the closing paragraph of *Time* magazine's report on Zambia's independence celebrations in that year, and included an interview with Edward Mukuka Nkoloso, a grade-school science teacher and the director of Zambia's National Academy of Science, Space Research and Philosophy, who claimed the celebrations interfered with his space program to beat the US and the Soviet Union to the moon. Nkoloso was training twelve Zambian astronauts . . . spinning them around a tree in an oil drum and teaching them to walk on their hands, 'the only way humans can walk on the moon.' At the time, no one knew what to make of it, and more interviews by other reporters 'did little to clarify', wrote the *New Yorker*, 'whether his space program was serious, silly, or a sendup.' But it caught a lot of attention.

When de Middel came across it much more recently, she wasn't sure what to think at first either. 'It attracted my attention precisely because my first reaction was, is it true or isn't it? And that is exactly the response I want from my audience when they see my work. I also like that it was an optimistic story about Africa, rather than the idea we more usually have of the continent.'

↑
Cristina de Middel
Umeko, from the series *Afronauts*, 2011

↑
Cristina de Middel
Butungakuna, from the series *Afronauts*, 2011

So, the way to photograph a story that died half a century ago with only a few documents remaining, is to bring it back to life.

'I thought, I have a story and I need images to support that story. On one hand I had the real documents and on the other I had images I wanted to create. As I saw it there are key Nasa images that we are familiar with — the flag and the footsteps on the moon. I tried to translate these and give them an African spirit.' – *Cristina de Middel*

The glass dome from an old streetlight became a helmet, abandoned concrete-mixing drums became space capsules, and de Middel commissioned her 92-year-old grandmother to make the spacesuits and the textile covering the rocket. To give factual 'depth', de Middel mixed up genuine and fake documents about the Zambian space program. 'I used an original press cutting, but changed Edward's face. The letters are real letters I found on the internet, but I retyped them with an old typewriter.' The resulting *Afronauts* series is affectionate and strange rather than poking fun.

Exploring identity

While we're in the world of invention and theatricality, there's always one model or actor who is always available — yourself. Indeed, people are photographing themselves by the million daily. However, employing yourself as a model to take on different roles is a very different approach, and opens up new worlds. The American artist-photographer Cindy Sherman has been doing precisely this since the 1970s. She photographs only herself, but made up and attired and altered (such as with prosthetics) to become many other people. She began with a series of black-and-white made up 'film stills' and has gone on to explore a diverse range of portrait genres from the glamorous to the grotesque.

With her own face and body centre stage, Sherman's appropriation of various different media styles (or clichés) has been a way of investigating the many processes of controlling appearance. She traces her interest back to her childhood, in which, largely because of age differences, she played alone, and felt a need to keep her family interested in her. 'I thought: if you don't like me like this maybe you will like me like this? With curly hair? Or like this?' This continued when she moved to New York, where she continued to experiment with different looks and different personae.

Inevitably, in her exploration of how different kinds of women present themselves, gender issues abound. She says, 'I think my work has often been about how women are portrayed in the media,' Sherman says, 'and of course you don't actually see that many portraits of older women or old women in fashion and film. So that's part of it.' So for all that Sherman's style has in common with the selfie, there's something much more interesting and empathetic going on here.

Easily dismissed by many photographers who have their sights set on higher ground, the lowly (though never humble!) selfie is not only the largest genre of photography by far, but in the hands of an imaginative few, it has opened a new style of creative shooting. Sherman's body of work, over 30 years and now lauded without exception by the art world, is established, and a benchmark.

↑

Cindy Sherman
Untitled #153, 1985

Reconstructed worlds

Karen Knorr, who used a form of staging in her *Belgravia* series to create satirical portraits (see Family Life, page 44), took the idea much further in a series of opulent and colourful photographs that set out to explore upper-caste India and Indian mythology. Like Belgravia, this is a privileged world, but the settings here are even more sumptuous and the inhabitants are not princes but India's wildlife. The access she was looking for was to a historical world that includes folklore and mythology, in which creatures such as cranes, zebus, langurs, tigers and elephants take on their old cultural and religious roles as avatars. 'I was very influenced by Gabriel García Márquez and his magical realism,' she says, worlds in which magic and folklore fit seamlessly into the 'normal' world.

Her aim was to photograph gorgeous interiors of palaces, havelis, mausoleums and temples in Rajasthan in a completely formal way — but to have wild animals strolling through or languishing in them. The only way to achieve this was to photograph interiors and animals separately, and digitally composite them. It is a combination of slow photography with long exposure times combined with the high-speed capture of wildlife. 'I take artistic license,' Knorr says. 'These are between document and magical realism, but they're all real.' She had to learn wildlife photography, an area unfamiliar to her, and to match the basic natural lighting inside. This was a long project, over several years: 'each one might take a month or two months to make.' Visually, the series is instantly attractive, but it also brings to life in a strange way the rich and complex Hindu mythology, in particular ancient animal fables that make up the Panchatantra, a widely known collection of morality tales in which animals take on human behaviour. Knorr adds, 'I wanted to have that jewel-like effect that is what Indian miniatures are about.'

Digital compositing is nothing new, but in this way it opens up the possibility of reconstructing — or suggesting — a fabulous world.

You wouldn't normally think of it as a means of access, but here it acts as a window on an otherwise unreachable world of magical realism.

↑

Karen Knorr
The Queen's Room, Zanana, Udaipur City Palace,
from the series *India Song*, 2010.

→

Karen Knorr
Avatars of Devi, Zanana, Samode Palace,
from the series *India Song*, 2010.

Frontline studio

Photojournalist Romano Cagnoni, a dear friend, always did things differently throughout his life, almost to the point where I'm still not sure that it's right to describe him as a 'photojournalist'. He resisted that kind of categorization, and liked to say, 'Is it not enough just to be a photographer?' According to Harold Evans, the editor of the *Sunday Times* from 1967 to 1981, Cagnoni was 'one of the five most important photographers of the 20th century' alongside Henri Cartier-Bresson, Bill Brandt, Don McCullin and W. Eugene Smith (see Obsession, page 78).

Part of Romano's *modus operandi* was to address a difficult situation by finding a solution that no one else would have thought of. As a young photographer in London, he managed to get a scoop when Elizabeth Taylor arrived with her fourth husband and checked into the Dorchester. Discovering that the newsworthy couple were on the sixth floor, Cagnoni found his way onto the roof with a strong assistant who tied a rope around his ankles and lowered him, upside down, until he reached the window of the stars' suite.

That was a trivial risk when compared with his mature work, which was typically in war zones. In 1965, as the first non-communist photographer to enter North Vietnam, he countered Ho Chi Minh's refusal to be photographed by telling him that people sensitive to justice would be happy to see him in good health. Ho Chi Minh replied that Cagnoni was an optimist, and as optimists make good revolutionaries, he could take the picture. When the Soviet army invaded Afghanistan in 1980, he walked around Kabul photographing troops with a concealed camera operated by a bulb. Then came the First Chechen War in 1995, when the Soviet Army attacked the capital, Grozny. How to cover this differently? His left-field solution was to set up a studio where the battle raged. He said:

'The idea came from my wife Patti . . . I set up a studio in Grozny during really hard times, with flash units and backgrounds. I used an interpreter to ask if them if they wanted to be photographed. Many accepted, they didn't pose, just stood there tired, dirty, tense, some of them wounded. I wanted to photograph them because they had

Romano Cagnoni
Hazmat, 30 years old, Grozny, 1995

such a great history. Tolstoy, Lermentov, Pushkin had written about these people. I also thought they were almost unreal, such young men against the Russian army.' – *Romano Cagnoni*

One of his portraits, of a smiling Chechen soldier, caused a diplomatic and political row when it was used on posters to promote a 2011 exhibition of his work in Milan. The Russian consulate complained to the city authorities claiming that the photograph was 'a senseless provocation', and the authorities decided to cover up the posters, in turn prompting an outcry from free speech campaigners.

'There was something else that I found very interesting. This man with a beard [overleaf] was not a Chechen. His name is Ali, a 30-year-old man from Tajikistan . . . He came to fight, to risk his life, for his Chechen friend, Mohamed. Another young man I photographed came to fight from Azerbaijan. He too came to help a friend.

↑

Ali, 31 years old, Grozny, 1995

These instances reminded me of characters in Greek mythology, like Achilles or Hercules . . . For me they weren't any longer just defenders of this little land. They were warriors in the classical sense of what we know from the history of art. That's why I arranged the lights almost like a Hollywood set.

'War is a fascinating, terrible situation. As a child I ran away with my family the day before the Nazis murdered all the villagers on the mountains in Tuscany, in the village where we were refugees to escape the Allied bombings. In photographing conflicts I always had the tendency to take the side of the poor.' – *Romano Cagnoni*

A few years earlier, he and Patti covered the war in Croatia, but again sought an unexpected way to get close to the heart of the subject. 'A war fought mainly with artillery was destroying a great deal of decent architecture . . . I had to show the beauty and the history of the architecture to communicate even more the sorry state of its destruction.' For this, Cagnoni, who like everyone else covering war zones shot 35mm (Leica, Nikon), turned to a 4 x 5-inch camera and large single sheets of negative film.

'Only with a large-format camera would I obtain ultra-sharp photographs, control the convergence of the lines etc. . . . The aim was to have technically perfect architecture photographs of war-damaged sites intending a disconcerting effect.' After publication in *Stern* magazine, he received the Art Director Club of Germany's bronze medal.

It's not only war zones that breed this kind of imaginative solution to desperate situations. Cagnoni did many gentler, less dramatic stories in his career, but he always looked for a way that no one else had thought of. He knew what had gone before and his starting point was not to repeat what other photographers had done.

My all-time favourite photographic advice came from the hugely influential art director of *Harper's Bazaar* from 1934 to 1958, Alexey Brodovitch. He said, 'If you see something you have seen before, don't click the shutter.'

Index

Picture Credits

The publishers would like to acknowledge and thank the following for permission to publish images in this book:

13 Weegee (Arthur Fellig)/International Center of Photography/Getty Images; 15, 16 © Matt Stuart; 19, 20–21 © Ju Shen Lee. @jushenlee/ jushenlee.com; 22, 23, 25 © Bob Mazzer; 33, 34–5, 36 © Patricia Pomerleau; 40, 42, 43 © Stuart Freedman; 45 Courtesy of Karen Knorr © Karen Knorr; 46 Pete Souza/The White House/Sipa/Shutterstock; 49, 50, 51 © Hazel Thompson; 53, 54 William Albert Allard/National Geographic; 79, 80 W. Eugene Smith © 1965, 2017 The Heirs of W. Eugene Smith/Magnum Photos; 83, 84 © Amos Schliack; 86, 88–9 © David Alan Harvey/Magnum Photos; 91 Peter Turnley/Corbis/VCG via Getty Images; 93 © David duChemin, craftandvision.com; 95 © The Estate of Garry Winogrand, courtesy Fraenkel Gallery, San Francisco; 97, 98 © Jennifer Barnaby. @jennifer.barnaby/jenniferbarnabyphoto. com; 105 © Matt Stuart; © 107, 108 © Xavier Comas; 117 © Howard Schatz and Beverly Ornstein 1998; 118 Photo: Tom Sperduto © 2015; 121, 122 © Jon McCormack. The Kilgoris Project, kilgoris.org; 125 © Reuben Wu. @itsreuben/reubenwu.com. Courtesy www.imiartists.com; 127 J. Paul Getty Museum, Los Angeles; 128 AF Archive/Alamy © Warner Brothers; 130 Reproduced with the permission of Haymarket Media Group Limited; 135, 136–7 © Stuart Paton; 139 © Joel Meyerowitz. Courtesy Howard Greenberg Gallery; 141 Collection Lannan Foundation © Thomas Joshua Cooper. Photo courtesy of the artist; 143 Charles Jourdan, Fall 1978 © Guy Bourdin Estate, 2020 via art+commerce; 145, 146 © Cristina de Middel/Magnum Photos; 149 © Cindy Sherman. Courtesy of the artist and Metro Pictures, New York; 151, 152–3, Courtesy Karen Knorr © Karen Knorr; 155, 156 © Fondazione Romano Cagnoni.

All other photography is © Michael Freeman.